MW00774992

LOTERÍA

HUASTECA

WOODBLOCK PRINTS

ALEC DEMPSTER

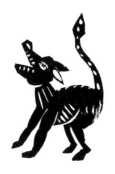

The Porcupine's Quill

Library and Archives Canada Cataloguing in Publication

Dempster, Alec, 1971–
[Prints. Selections]
 Lotería Huasteca : woodblock prints / Alec Dempster.

Includes bibliographical references.
ISBN 978-0-88984-383-7 (paperback)

 1. Dempster, Alec, 1971–. 2. Huasteca Region (Mexico)—
In art. 3. Lotería (Game). I. Title. II. Title: Huasteca.

NE1336.D46A4 2015 769.92 C2015-904169-4

Copyright © Alec Dempster, 2015.
1 2 3 • 18 17 16

Published by The Porcupine's Quill, 68 Main Street,
PO Box 160, Erin, Ontario NOB 1TO. http://porcupinesquill.ca

All rights reserved. No reproduction without prior written permission of the
publisher except brief passages in reviews.

Represented in Canada by the Canadian Manda Group.
Trade orders are available from University of Toronto Press.

We acknowledge the support of the Ontario Arts Council and the Canada
Council for the Arts for our publishing program. The financial support of the
Government of Canada through the Canada Book Fund is also gratefully
acknowledged.

Canada Council Conseil des Arts
for the Arts du Canada

ONTARIO ARTS COUNCIL
CONSEIL DES ARTS DE L'ONTARIO
an Ontario government agency
un organisme du gouvernement de l'Ontario

Canadä

Ontario
Ontario Media Development
Corporation

This book is dedicated to three dear friends in Mexico, for their on-going support and inspiration. Visual artist José Chan's profuse and independent artistic imagination has motivated me to follow my own intuitive path. Boundless generosity and contagious enthusiasm patently describe architect and *jaranero* Mario Artemio Morales. With Arturo Castillo Tristán's guidance my understanding of the Huasteca continues to deepen.

I would also like to mention some of the people without whom this book would not exist. Arturo Castillo and Blanca Barrón offered hospitality, friendship and poetry in Citlaltépec. Alantl Molina in Mexico City was available whenever I called on him to comment and correct. My guides in Xalapa, Román Güemes Jiménez and Nelly Iveth del Ángel Flores, have given me advice and orientation from beginning to end. Miles Dempster made crucial editorial suggestions throughout the writing process. I am thankful to Chandra Wohleber for her enthusiastic correction of the manuscript. Tim and Elke Inkster have given me the opportunity to share both my vision of Mexico and my deepening understanding of the country's diverse culture. Financial assistance from the Ontario Arts Council facilitated the completion of the manuscript.

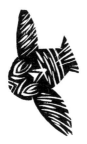

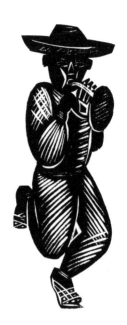

TABLE OF CONTENTS

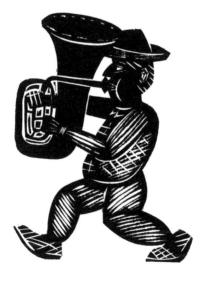

INTRODUCTION

My first foray into the Huasteca region began with an overnight bus journey from Xalapa, the capital of the state of Veracruz. Sleep was difficult due to stops in small towns along the way, and when the bus arrived at my final destination in Naranjos it was still dark. I dragged my feet and belongings to a place by the curb, beside a tower of freshly made rounds of white cheese placed carefully between moist banana leaves.

Eventually, a pickup truck parked in front of the terminal and the driver was greeted enthusiastically by a group of fellow travellers who had assembled around me. It turned out that we were all headed for the same music festival in 'Citla', an hour's drive up into the hills. Most of us clambered into the back, and from there we were privy to a majestic sunrise over the rolling hills of the Otontepec mountain range. I had no idea I was setting out on a journey that would eventually result in a book, nine years later.

At the time I was familiar with *son huasteco* music, having listened to the legendary Trio Xoxocapa at La Sopa restaurant in Xalapa on many a Friday evening. My understanding of the huasteca region was facilitated by Arturo Castillo Tristán (a retired elementary school teacher, poet and cultural promoter), from whom I received a surprise phone call in 2004. Arturo began by explaining that he was calling from Citlaltépec, and that he admired the artwork and recordings I had done related to the culture of southern Veracruz. He invited me to attend the upcoming *son huasteco* festival he was organizing, and enticed me with a place to stay and food to eat, as well as a space to exhibit my prints. This was an offer I could not refuse. A few weeks later I was in Citlaltépec, where I quickly grasped Arturo's real motive, which was for me to become enamoured of the region, its people and its music. Arturo, who was familiar with my *lotería jarocha* game, was eager for us to work together in the creation of a *lotería huasteca* based on the *huasteco* musical repertoire.

Lotería is a game of chance similar to bingo, with origins in Italy and Spain. It has been played in Mexico since the seventeenth century by people from all walks of life and differs from bingo in that each

board has a grid of images rather than just numbers. The illustrated cards are pulled from the deck by a caller, who recites phrases alluding to a standard series of fifty-four images that include the frog, the ladder, the moon, the deer, the soldier and the sun. There are stock phrases such as, 'The blanket of the poor ... the sun!' and 'A shrimp that sleeps is carried away by the current ... the shrimp!' But the caller can also improvise. There are several ways to win, such as being the first person to have all nine images, making a row of three in any direction or by getting the four corners.

A few pesos may be pooled at the start of each round, increasing the thrill of a possible win. *Lotería* sessions are also held to raise funds for initiatives such as refurbishing a church. Money is collected from the participation fee and the players vie for prizes that have been donated to the fundraiser. To this day the game's popularity hasn't waned; it can be purchased at market stalls or stationery shops all over Mexico.

Initially I hesitated to embark on the project since the culture of northern Veracruz and the rest of the Huasteca was foreign to me, unlike *son jarocho*, the folk music from southern Veracruz, which had become second nature after prolonged immersion, marriage and an inexplicable affinity for the music. The thought of the months it would take to create a completely new series of fifty-four prints for another *lotería* was also a consideration. Nonetheless, the ebullient weekend in Citlaltépec was all it took for me to commit to the project. I succumbed to the percussive throb of collective dancing, the nimble fantasia of countless violinists, impromptu poetic duels between singers, an eye-opening stroll through a *huastecan* market and my first taste of *zacahuil* (an enormous tamale usually reserved for special occasions).

Back in Xalapa, I began in earnest by compiling a list of the traditional songs, called *sones huastecos*, that I thought might illustrate the new *lotería*, only to discover that several had the same titles as the *sones jarochos* constituting my *lotería jarocha*. To distinguish the two games, Arturo and I decided to focus on the region's cultural diversity rather than limit the project to *son huasteco*, which is only one of the many components that define the Huasteca. With the help of *huasteco* scholars Román Güemes Jiménez and Nelly Iveth del Ángel

Flores, I assembled a long list of potential subjects for the prints, which was whittled down to the fifty-four illustrations included in this book.

Although the territory explored here evades succinct definition, several characteristics help to place the images and texts within an ample context. The geography of the Huasteca stretches inland from the Gulf of Mexico around the Pánuco River basin into the states of Veracruz, Hidalgo, San Luis Potosí, Puebla, Querétaro and Tamaulipas. Its elusive contours resist precise mapping while the political boundaries of these six states intersect it with disregard. The population is an ethnically and linguistically diverse convergence of Teenek, Otomí, Nahua, Tepehua, Pame and Totonaco peoples living together with mestizos. Consequently there are many internal maps within the broader region, which is defined by language, religion and culture along with shared traits resulting from centuries of co-existence. This book focuses both on shared traditions and on those that are specific to the distinct cultures within the area.

Today it is primarily the mestizo population that refers to itself as *huasteco* (from the Nahuatl *kuextekatl*), although the Teenek are the people that have been referred to historically as *huastecos*. There is ongoing debate as to the origin of the term *huasteco*, which could derive from *cuextli* (a snail with an elongated shell), Kuextekatl (a mythical leader) or *huaxin* (a type of tree). The Huasteco or Teenek language, a branch of Proto-Mayan, has been spoken in the region for about 3,600 years.[1]

At the time of the Spanish conquest the Aztecs referred to the area as Cuextlan and the inhabitants as *cuextecas*. The ancient *huastecos* governed a multi-ethnic kingdom structured around small independent states that resisted multiple invasions from central Mexico until 1506, when they became tributaries to the Aztec empire. Only a decade later they faced new invaders when the first Spanish conquistadores appeared at the mouth of the Pánuco River. Initial attempts at conquest by the Spanish were repelled until Hernán

1. Ramírez Castilla, Gustavo A. 'La Huasteca prehispánica.' *La Huasteca: Una aproximación histórica.* Mexico: Programa de Desarrollo Cultural de la Huasteca, 2003. 15.

Cortez sent Francisco de Sandoval to subjugate the Huasteca with an enormous army that succeeded with the help of Tlaxcalteca, Cholulteca and Mexica allies.

In 1525 Nuño Beltrán de Guzmán was appointed governor of Pánuco.[1] He is notorious for having orchestrated an extensive slave trade that contributed to the decimation of the local population. An estimated forty thousand indigenous men and women were exchanged for cattle and shipped to different parts of the Caribbean to work in mines.

In response to a catastrophic decline in the population of what is now Mexico, the Spanish rulers of the sixteenth century passed legislation to limit the enslavement of indigenous peoples. African slaves were used instead, while the dwindling indigenous population was still subject to multiple forms of exploitative labour. In addition, efforts to eradicate indigenous religions and customs continued. Part of this strategy involved the displacement of indigenous communities to new administrative settlements built around convents and churches.[2] These and other measures certainly took their toll but were met with continuous opposition.

Today, a remarkable kaleidoscope of indigenous culture has resulted from the determined resistance of individuals and communities over centuries. This book celebrates that continuous resilience and is intended to provide one more of many possible ways to envision the Huasteca.

1. Güemes Jiménez, Román. Introducción. *La Huasteca: Una aproximación histórica*. Mexico: Programa de Desarrollo Cultural de la Huasteca, 2003. 10.

2. Pérez Zevallos, Juan Manuel, and Artemio Arroyo Mosqueda. 'La Huasteca bajo el dominio de la corona Española.' *La Huasteca: Una aproximación histórica*. Mexico: Programa de Desarrollo Cultural de la Huasteca, 2003. 42.

THE PRINTS

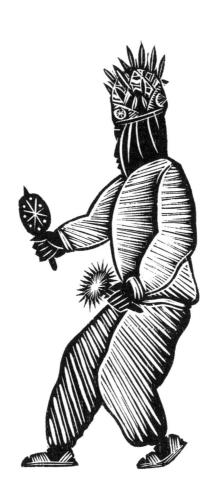

LA ACAMAYA

The word *acamaya* derives from the Nahuatl *acamaitl* meaning 'reed arms', referring to the very long claws of the crayfish. These crayfish can be found hiding under submerged stones along shady riverbanks throughout the Huasteca. Whether it is fried *al mojo de ajo* (in garlic sauce) or boiled in a spicy broth called *chilpachole*, this freshwater crustacean is a delicacy sought after in the states of Veracruz, Tamaulipas and Querétaro. They are caught in a handcrafted trap called a *colote*, or 'basket', woven from the tender branches of the *tenaza* tree, which are cut during the new moon. Once the *acamaya* ventures through a small opening in the trap its fate is sealed. Fishing for the *acamaya* is easier from October to February when water levels are low, and the traps are set at night to take advantage of its nocturnal feeding habits.[1]

The *acamaya* appears in one of the countless myths of Chikomexochitl, the corn god, often portrayed as a child who lives with a malevolent grandmother who sends the child on one perilous journey after another in the hope that he should perish. On one such adventure he spars successfully with the *acamaya* and returns with a claw transformed into a rattle.[2] In some versions of the Chikomexochitl myth he is killed but is later reincarnated in the form of the corn plant.

1. Hooft, Anuschka van't. 'Xili.' *Lengua y cultura nahua de la Huasteca*. n.d. Accessed on the Web, July 22, 2013.
2. Hooft, Anushka van't. 'Chikomexochitl y el orígen del maíz en la tradición oral nahua de la Huasteca.' *Destiempos*. 2008: July–August. 53–54.

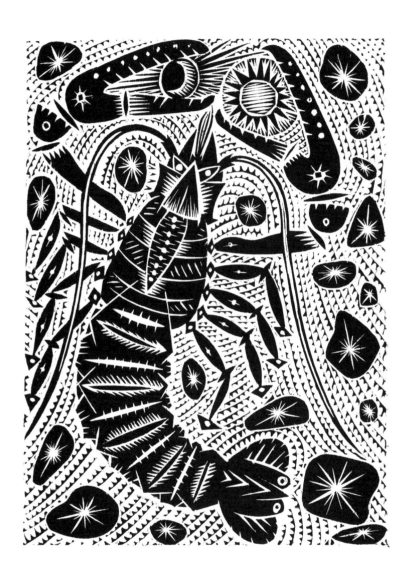

EL ALGODÓN

Here, raw cotton is being transformed into a spool of thread destined for weaving. The plant, once central to the culture and economy of the Huasteca, was a valuable commodity when woven into fabric and along with cacao it was used as currency. After conquest by the Aztec Empire, the inhabitants of the Huasteca were forced to supply their rulers in Tenochtitlán with large quantities of the raw and woven fibre. The Aztecs considered it an exclusive material to dress in, reserved for the ruling class. During the sixteenth and seventeenth centuries, the Spanish continued to demand exorbitant payment of this tribute.

Today, cotton is used ceremonially in a Nahua rain-invocation ritual called *tlaajaltilistli*, meaning 'bath'. During the ritual, wet cotton cloths are used to bathe images of Catholic saints. The water used during the ceremony is collected in a bowl made from a gourd and sprinkled in the four corners of the house.[1] Upland cotton, the most common variety of the plant, native to Mexico and Central America, is known in Nahuatl as *cuauichkatl*. There is also a coffee-coloured plant called *coyoichkatl*, a variety of cotton known as ELS (extra-long staple) that has a fibre length of 1 3/8" or longer. The word *ichkatl*, which means 'cotton', also refers to the god of weaving and clothing.

1. Gómez Martínez, Arturo. *Tlaneltokilli: la espiritualidad de los nahuas chicontepecanos.* Mexico: Ediciones del Programa de Desarrollo Cultural de la Huasteca, 2002. 115.

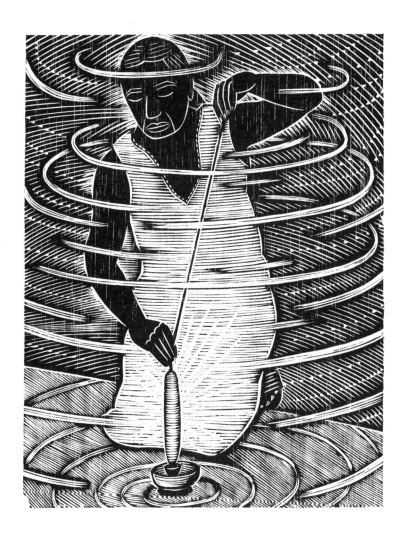

EL AMATE

A distinctively Mexican type of paper is made from the inner bark of the *amate* tree (*ficus insipida*). The name of the tree comes from the Nahuatl word *amatli*, meaning both 'paper' and 'document'. *Amatli* was paid as tribute by the Huastecos to the Aztec Empire, which used large quantities for ceremonies and codices. Pre-Columbian codices were pictorial documents with detailed information regarding rituals and used for divination. Most of these codices were burned indiscriminately during the Spanish conquest, and the subsequent use of *amate* paper was strictly controlled.

In spite of prohibitions this laborious paper-making tradition and the ritual use of *amate* has been maintained in a few communities. The paper is made by tearing the bark into long strands which are then boiled in caustic soda. Multiple strips are laid out on wooden boards and pounded with a flat stone into thin sheets of varying sizes. The colour of the final product is either light brown or cream with a fairly smooth surface and irregular edges.

Today Otomí shamans continue to cut out small figures from *amate* paper to represent a pantheon of gods associated with agriculture, rain and mountains. In San Pablito, a community in the municipality of Pahuatlán, Puebla, famous for *amate* paper, the paper figures are used to intercede with the gods for purposes of healing, protection and spiritual purification.[1] Rituals are performed at sacred sites, such as mountains, where the paper is sprinkled with the blood of sacrificial fowl and *hule* (natural latex from a rubber tree).

1. Gómez Martínez, Arturo. 'El arte popular contemporáneo.' *Las artesanías de la Huasteca veracruzana*. Ed. Sofía Larios León. Xalapa: Consejo Veracruzano de Arte Popular, 2006. 58.

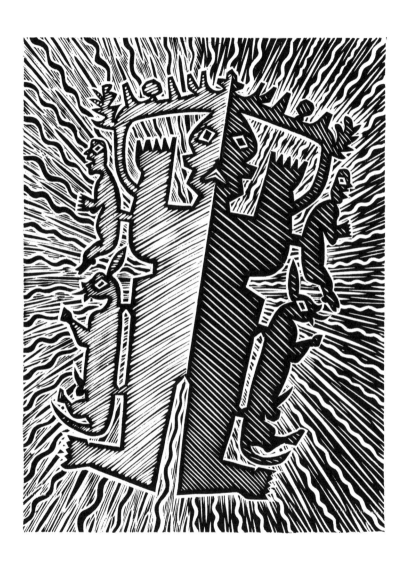

EL ÁRBOL FLORIDO

Belief in a cosmic tree, associated with the *ceiba*, was fundamental to an ancient Mesoamerican world view. The mythological tree grew at the centre of a primordial paradise called Tamoanchan. One version of the myth describes how several gods disregarded the proscription against cutting the tree's flowers and as a result were banished to the earth and the underworld. This event is depicted in several codices as a bleeding tree with flowering branches. A similar mythical tree figures prominently in the embroidery of the Huasteca but without any severed flowers or branches. Among the Nahuas it represents a cosmic order, and is also known by the Nahuatl term *tonacaxochicuahuitl*[1] ('tree of life') or *xochicuahuitl* ('flowering tree').

It is a life-giving plant bearing an abundance of fruit and surrounded by a variety of animals. Teenek women in San Luis Potosí embroider this imagery on their clothing. The tree also represents a tripartite division of the universe: the underworld, where the roots penetrate; the mountain on which the tree grows and where the earth's riches are stored; and the heavens, which are touched by its highest branches. The gods and the ancestors are able to travel up and down its trunk, along its branches and around the roots.[2]

1. López Austin, Alfredo. *Tamoanchan y Tlalocan*. Mexico: Fondo de Cultura Económica, 1994. 87.

2. Gómez Martínez, Arturo. *Geometrías de la imaginación. Diseño e iconografía de Puebla*. Mexico: Consejo Nacional para la Cultura y las Artes, 2009. 13.

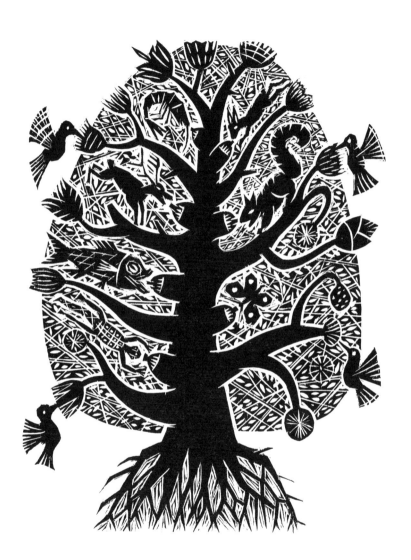

LA BANDA DE VIENTO

The brazen music of the Huasteca's brass bands is synonymous with the euphoria of open-air celebrations such as carnival and Xantolo. Many towns and villages in the states of Hidalgo, Veracruz and San Luis Potosí have municipal bands rooted in Mexico's colonial history. The sixteenth century saw the establishment of church-based instrumental ensembles in many indigenous communities conforming to a chapel-based education system practised in the cathedrals of Seville and Toledo.[1] Although these orchestras were part of a program of evangelization, they became a tool of resistance and reintegration that still functions as such.

The coalescence of European instruments with local musical concepts produced new genres that strengthened cultural identity. Today, during civic, festive and solemn occasions the band continues to play a unifying role. The effervescent popularity of the music is most evident during an annual festival and competition of bands in Calnali, a small town of about 12,000 inhabitants, in the state of Hidalgo. San Marcos, the town's patron saint, is honoured with *huapangos, sones huastecos* and carnival music, which make up the bulk of a repertoire adapted to the band format over the course of the last hundred years.

1. Navarrete Pellicer, Sergio. 'La modernización del estado y sus rituales sonoros: las capillas de viento y los cuerpos filarmónicos en Oaxaca.' *Las músicas que nos dieron patria*. Ed. Miguel Olmos Aguilera. Mexico: Ediciones del Programma de Desarrollo Cultural de Tierra Caliente / Dirección General de Publicaciones de Conaculta, 2012. 83–98.

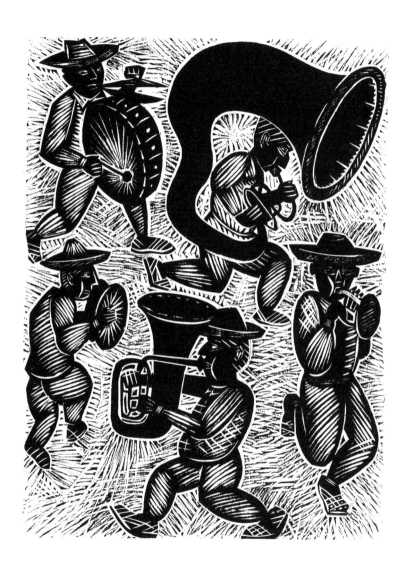

LOS BOCOLES

El bocol, from the Teenek word *bókol*, is popular food throughout the Huasteca. The tasty mouthful falls into a category called *antojitos*, meaning 'little cravings', that usually have corn as a main ingredient. *Bocoles* are dispatched quickly at market stalls and also prepared in the home. In other parts of Mexico a common but slightly larger equivalent is called a *gordita*. The basic recipe involves kneading lard and salt into *masa*, a dough made from corn that has been cooked with lime, also used to make tortillas. Shaped into small cakes and cooked on a large flat metal or clay pan called a *comal* until brown on both sides, they can then be cut in half and filled with meat, beans, cheese or just salsa. *Bocoles* may have the filling already combined into the *masa* in one of two forms: *etexmimil* (filled with ground black beans) and *eneles* (filled with whole black beans).[1] Similar dishes exist across Latin America, such as the Venezuelan *arepa* and the *pupusa* from El Salvador.

1. Güemes Jiménez, Román. *Cultura desocupada: tirada para el solar Huasteco.* Veracruz: Instituto Veracruzano de la Cultura, 2005. 44.

EL BORDADO

Like pottery and weaving, embroidery is mainly the domain of indigenous women whose craft has served to preserve the iconography of their peoples. The representation of mythical animals such as the tiger-bird and the two-headed eagle are part of the graphic heritage that has been painstakingly passed on for centuries. A variety of embroidery techniques are used to embellish clothing and household articles such as tablecloths and napkins. In Chicontepec, a small town in the state of Veracruz, ceremonial use of textiles includes miniature clothing for paper representations of various gods. The garments are embroidered with specific designs that follow an established colour scheme.[1] Traditionally the palette was limited to a few natural dyes, but the introduction of machine-made fibres and glass beads in a wide range of colours was transformative. As well as expressing a deeply rooted cultural identity, embroidery can supplement household income. While the product is chiefly sold through intermediaries, women also sell their wares directly at regional festivals where the popularity of the embroidered garments transcends cultural and economic boundaries. Recent compilations of designs associated with specific regions and communities have been published to help conserve this heritage, at odds with the growing preference for factory-made clothing.

1. Gómez Martínez, Arturo. 'El arte popular contemporáneo.' *Las artesanías de la Huasteca veracruzana.* Ed. Sofía Larios León. Xalapa: Consejo Veracruzano de Arte Popular, 2006. 68.

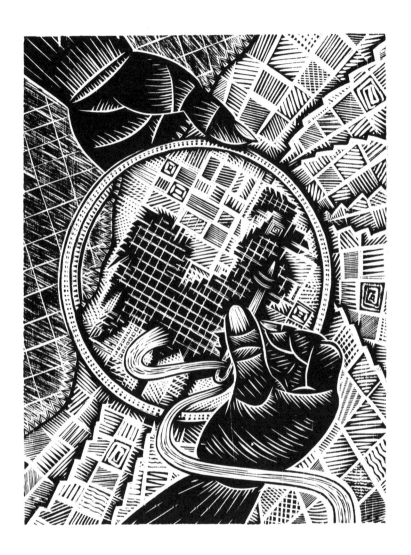

EL CAIMÁN

Mention *el caimán* in the Huasteca and most people will think of a vigorous *son huasteco*. Popular among dancers eager to flaunt their prowess, it is also a showpiece for singers. The verses evoke the reptile's aquatic habitat and name specific places in the Huasteca.

El caimán está muy viejo	Although he's very old
pero así se anda casando	the caiman is getting married
con una de Pueblo Viejo.	to a woman from Pueblo Viejo.
La fiesta están celebrando	The party is under way
en la casa de un cangrejo,	in a big crab's house
las jaibas andan bailando.	female crabs are dancing.

The old caiman also appears in ancient Mesoamerican mythology. According to an Aztec myth, the original substance of the universe was Cipactli, an enormous female caiman or fish, who was cut in two by Quetzalcoatl and Tezcatlipoca. After a reorganization of the universe a middle section, between the severed parts, became the domain of humans.[1]

The caiman also appears along with the corn god in a Tepehua myth. During an encounter with the caiman, the corn god cuts the caiman's tongue off, after which Saint Peter allows the corn god to enter the Land of Thunder. By waving around the severed caiman tongue the corn god is able to summon clouds and intensify the thunder and lightning. The old lightning gods that inhabit the land are quite upset by this and ask Saint Peter why he permitted this interloper to have such power. They can't oppose the creation of storms but ask that use of the caiman's tongue be divided equally among them.[2]

1. López Austin, Alfredo. *Los mitos del tlacuache: caminos de la mitología mesoamericana.* Mexico: Alianza Editorial Mexicana, 1996. 74.

2. López Austin, Alfredo. 'Homshuk. Análisis temático del relato.' *Anales de Antropología.* Vol. 29, No. 1. Mexico: 1992. 255.

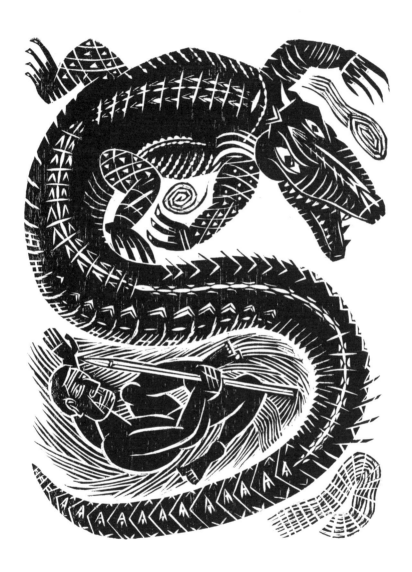

LA CAÑA

After silver and gold, sugar cane quickly became the most valuable commodity in early colonial Mexico. At the beginning of the seventeenth century this crop was popular in the European market where the sweetener fetched very high prices. Indigenous farmers soon started planting and processing sugar cane for their own consumption.[1] Within ten years, a sweet tooth and penchant for *aguardiente* among the local population helped to create a thriving regional market. Together with the introduction of cattle farming, sugar cane plantations severely transformed the Mexican landscape. Since the colonial era they have been the main cause of deforestation in the Huasteca.

The two main byproducts of the plant continue to be *piloncillo* and *aguardiente. Piloncillo* or 'jaggery', in English, is unrefined sugar produced by boiling the juice extracted from the sugar cane. It is sold in the form of hard cones that are made by pouring the hot liquid into moulds where it solidifies. Unlike refined sugar it has a distinct flavour that can be savoured in baked goods and dishes such as boiled pumpkin and sweet tamales. *Aguardiente* is distilled from fermented cane juice. Stills, scattered throughout the states of Veracruz and San Luis Potosí, continue to produce this inexpensive alcohol, which is consumed at all kinds of celebrations. The offering of *aguardiente* is a way of binding contracts and establishing bonds between people in the community.

1. Aguilar Rivera, Noé. 'La caña de azucar y sus derivados en la Huasteca San Luis Potosí México.' *Diálogos, Revista Electrónica de Historia.* Vol. 11, No. 1. San Pedro, Costa Rica: 2010: 86–87. Accessed on the Web, Jan. 13, 2014.

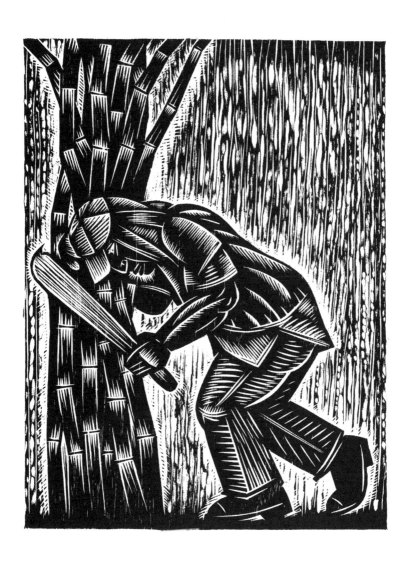

EL CAPORAL

El caporal, meaning 'foreman', is the term applied to a man entrusted with running a ranch. Arturo Castillo Tristán, the poet who prompted the creation of this *lotería*, refers to him as 'the soul of the ranch: a jovial and fun-loving cowboy who milks cows, herds cattle, competes in rodeos and listens to *música ranchera*. Frank and honest by nature, he is saintly when treated well and unforgiving when double-crossed.'

Cattle were introduced to the flat stretches of the region during the early colonial period, with devastating consequences for the local population. The fact that colonial authorities allowed ranchers to use fallow terrain as pasture led to the successive expropriation of fertile indigenous land.[1] Indigenous communities were forced to retreat to more isolated enclaves, leaving extensive areas of sparsely populated savannah. This became the domain of *el caporal*, who would spend most of his time on horseback moving cattle across the plains in search of green pastures. *El caporal* is also the name given to the musician and spiritual leader of the *voladores* ceremony.

1. Ariel de Vidas, Anath. *Huastecos a pesar de todo*. Mexico: Centro de Estudios Mexicanos y Centroamericanos, 2009. Ch. 3, par. 25. Accessed on the Web, Dec. 10, 2013.

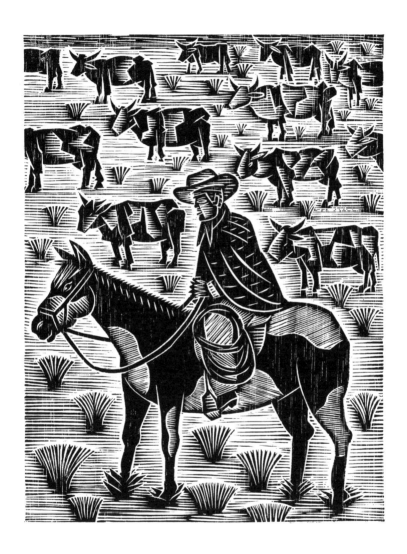

EL CARNAVAL

Carnival in the Huasteca precedes the Catholic celebration of Lent, and the complex celebration has more to do with indigenous purification rites and preparation for a new agricultural cycle. Besides the masked revelry, challenging of authority and subverting of social norms common to most carnivals, this is a time when the souls of the deceased and spirits from the underworld are believed to roam freely among the living. Mythological entities from a remote past and spirits are invoked and honoured.

Carnival is referred to as a 'game' played by the dancers who assume various roles such as *huehues* and *mecos*. The Nahuatl word *huehue* means 'elder', and the dancers who represent them are imbued with healing powers.[1] *Mecos* are ancestral warrior figures bearing long lances whose bodies are traditionally painted with pigments extracted from the earth.

Carnival is known as 'the Devil's festival' by the Otomí. However their Devil, called Zithu, is an entity associated with death, fertility, sickness and abundance. He is also referred to as the 'venerable ancestor' and the 'bull'. By taking part in carnival, Otomí dancers strive to placate nature's destructive forces and ensure a plentiful harvest.[2]

1. Croda León, Rubén. 'Una mirada a los carnavales indígenas del norte de Veracruz.' *Los rostros de la alteridad*. Ed. Lourdes Baéz Cubero and María Gabriela Garrett Rios. Veracruz: COVAP, 2009. 149–53.

2. Garret Rios, María Gabriela. 'Poder y control social en el carnaval de San Antonio el Grande, Huehuetla.' *Los rostros de la alteridad*. Ed. Lourdes Baéz Cubero and María Gabriela Garrett Rios. Veracruz: COVAP, 2009. 469.

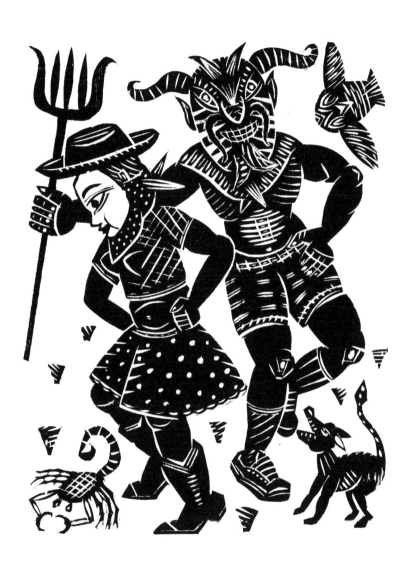

LA CASA

As well as providing shelter, the house is a sanctuary where ancestral beliefs are maintained and communal bonds are reinforced. Its construction often involves a group of men from the community who are offered food and *aguardiente* in exchange for their labour. Most houses have a rectangular floor plan, and the area under the pitched roof is used to store surplus from the harvest together with assorted tools. Building materials and the organization of the interior space vary according to the community and the family's resources. Once the house is built, it is customary for a ritualist to conduct a ceremonial inauguration, which includes the construction of a special altar, offerings of food, *aguardiente*, prayers and candles. The Teenek believe that for a house to be suitable for occupation it must be given a soul. This is achieved through a ceremony that features the offering of a tamale made with the heart of a rooster 'that hasn't sinned'.[1]

A common feature in every home is the household altar, around which the family's connection with the ancestors and other sacred entities is reaffirmed throughout the year. Temporary altars may also be assembled in the home for specific ceremonial occasions such as Xantolo, weddings, carnival and planting.

1. Hernández Azuara, César. 'Ritual de curación Teenek por medio de las danzas Pulikson y Tzacamson.' *Revista de Literaturas Populares.* Vol. 10, No. 1–2. Mexico D.F.: 2010. 141.

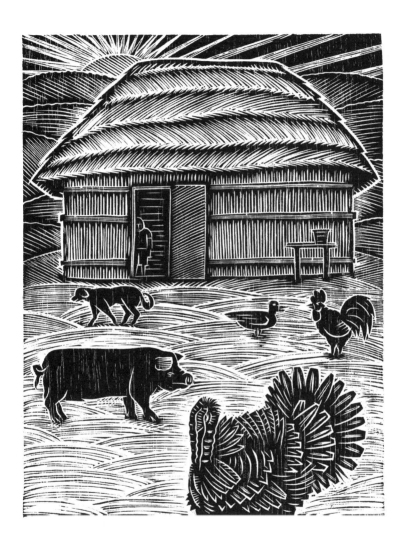

EL CERRO

A significant portion of the Huasteca is located in a mountainous area that stretches across the Sierra Madre Oriental. During the sixteenth and seventeenth centuries this rugged terrain became a place of refuge from the incursion of Spanish colonizers, missionaries and cattle farming. While the area is culturally diverse, centuries of coexistence have resulted in shared practices and beliefs. This is exemplified by the veneration of mountains [*cerros*], which represent a tripartite division of the universe into the heavens, the earth and the underworld.

Certain mountains are the abode of gods, such as Apanchaneh (the water goddess), Mixtli (the cloud god) and Tlatomonihketl (the thunder god). Collective rituals honouring these deities are intended to ensure bounteous harvests, sufficient rain and good health. Postectli, a sacred mountain located in the municipality of Chicontepec in Veracruz, is venerated by Nahuas, the Otomí, Tepehuas and Totonacos. The mythological Postectli was so high that humans would scale it to spy on the gods and steal their sacred food. To prevent this from happening, the gods divided Postectli into a number of smaller mountains.[1] Special powers are attributed to them all and a divination process conducted by a healer may reveal to which *cerro* a patient must go to make an offering as part of a treatment.[2]

1. Gómez Martínez, Arturo. *Tlaneltokilli: la espiritualidad de los nahuas chicontepecanos.* Ediciones del Programa de Desarrollo Cultural de la Huasteca. Mexico: 2002. 106.

2. Durán Ortega, Alejandro. 'Cerros sagrados y sones. Apuntes etnográficos.' *Lengua y Cultura Nahua de la Huasteca.* Prod. Anuschka van't Hooft. Mexico D.F.: CCSYH-UASLP/Linguapax/CIGA-UNAM, 2012. 4. DVD Multimedia.

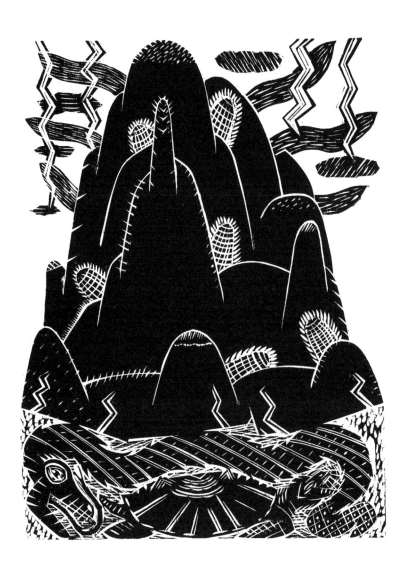

EL CHICHAPAL

A *chichapal* is a large sturdy clay pot without handles, used for cooking *frijoles* and tamales as well as preparing coffee and *atole*. The characteristic black patina acquired from the smoke of the wood-burning stove gave rise to the expression *'Negro como un chichapal'* ('As dark as a *chichapal'*, that describes a very dark place or a difficult situation.[1] Pots are fired using the ancient pit-kiln technique, requiring placement of the clay pieces on stones, which are then covered with firewood and shards of discarded pots to help contain the heat. While a *chichapal* is usually undecorated, some potters apply *atole de maiz negro*, a hot liquid (that can also be drunk) made from blue corn, to create an attractive finish.[2]

Until recently, the ability to make pots and other clay utensils was a skill all women were expected to acquire prior to marriage. Although this prerequisite has been abandoned, the whole process, which includes extracting the raw materials from the earth, is still the domain of women. Many communities, such as Chililico in the state of Hidalgo, have a long history of producing ceramics; archaeological excavations reveal how little pottery techniques have changed since the arrival of Europeans.[3] Other clay utensils produced in the Huasteca are *chilcajetes* (clay mortars for grinding spices), *comales* (large pans on which tortillas are cooked), candle holders, pitchers and toys.

1. Rivas Paniagua, Enrique. *Lo que el viento nos dejó: Hojas del terruño hidalguense*. Pachuca: Universidad Autónoma del Estado de Hidalgo, 2008. 44.

2. Güemes Jiménez, Román. *Cultura desocupada*. Veracruz: IVEC, 2005. 50.

3. Gómez Martínez, Arturo. 'El arte popular contemporáneo.' *Las artesanías de la Huasteca veracruzana*. Ed. Sofía Larios León. Xalapa: Consejo Veracruzano de Arte Popular, 2006. 35.

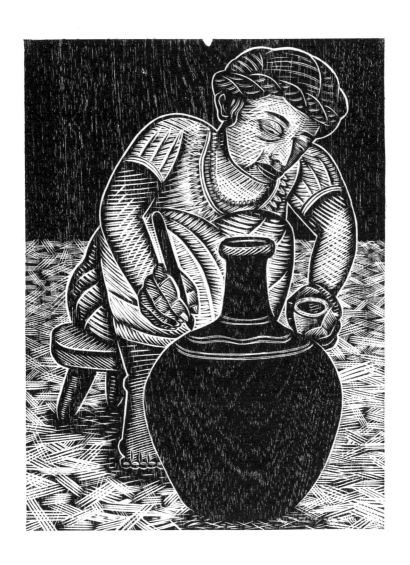

EL CHIQUIHUITE

Chiquihuite, borrowed from the Nahuatl *chiquihuitl,* is a word used all over Mexico to refer to a basket made from natural fibres. It may be a small basket with a lid, used to keep tortillas warm on the table, or an enormous container used in harvesting fruit. The latter is featured in this illustration and can be seen in an imposing landmark when entering Alamo, a town in Veracruz known as 'the orange capital' of Mexico. A colossal concrete sculpture of a man carrying a *chiquihuite* on his back pays homage to local farmers. Enormous oranges descend from the basket he is emptying in a frozen cascade that resembles an avalanche of cannonballs.

In Nayarit *chiquihuite* is a type of cheese so called because of the characteristic imprint left on the surface once the cheese has solidified in its basket. For the fabrication of *chiquihuites,* the chosen material will depend on its intended use and what plants are available locally. Different types of reeds (*carrizo*) or vines (*bejuco*) are the most common materials. This print also features the *mekapali,* an accessory often used in combination with the *chiquihuite* when transporting heavy loads. It consists of a thick strap that shifts some of the cargo's weight to the forehead.

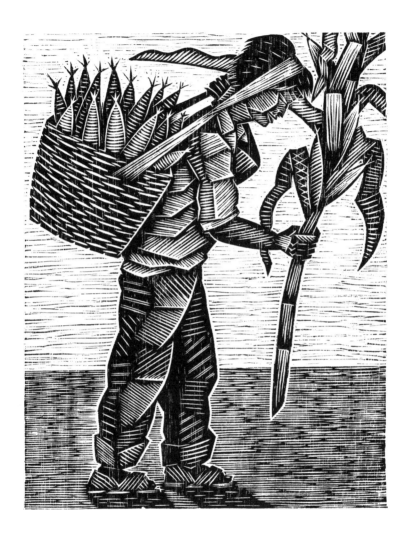

LA COCINA

The daily ritual of cooking tortillas on a clay pan over a wood-burning stove is not exclusive to the Huasteca. The scene depicted in this print is characteristic of rural Mexico as a whole. However, there are many other preparations of corn that constitute the unique gastronomical culture of the region. Here are just a few examples of the wide variety of tamales: *cuiches* (*masa* mixed with tender black beans), *elotamales* (a combination of *masa* and fresh corn), *tamal de cazuela* (made in an earthenware pot and cooked in a wood-burning oven) and *chojoles* (sweet tamales combining *masa* and *piloncillo*). Other regional specialties using corn as a base include *pemoles* (cookies made with *masa* and lard) and *estrujadas* (handmade tortillas dipped into hot salsa and then cut into small pieces).[1] Corn is also prepared in many ways for ritual occasions such as Xantolo in November when *zacahuil* is an important feature of traditional *ofrendas*. For the harvest festival in Chilocuil, a community in the municipality of Tamazunchale in the state of San Luis Potosí, several large tamales called *patlaches* are taken to the field to thank the gods of the earth.[2]

1. Herrera Silva, Armando. 'Three moments in the history of the Huastec region.' *Voices of Mexico*. Mexico: 2006. 83.
2. Camacho Díaz, Gonzalo. 'Dones devueltos: música y comida ritual en la Huasteca.' *Itinerarios*. Vol. 12. Varsovia: 2008: 74. Accessed on the Web, Jan. 16, 2014.

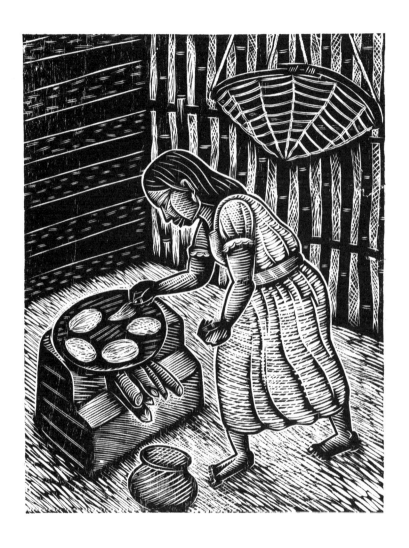

EL COPALERO

This small clay goblet, used as a censer, is found on household altars. During celebrations such as Xantolo, small pieces of crystallized tree resin are kept smouldering in the *copalero* to provide a continuous emanation of aromatic smoke. The smell of incense permeates the room, and rays of light slipping through the open door slice into the hazy atmosphere. *Copal* resin, from the Nahuatl *copalli* meaning 'incense', is tapped from a family of trees called *burseraceae*, native to Mexico. Its uses are both ceremonial and therapeutic. Important occasions start with an offering of *copal* to the four cardinal directions, followed by the ritual purification of each person in a bath of smoke. All four corners of a newly built house should also be purified with *copal*. If a bad fall has dislodged the soul, *copal* is used as part of the treatment to help put it back in place. In the hands of a shaman the trail of smoke rising from the *copalero* becomes a conduit facilitating communication with the gods. In addition, a variety of ailments such as measles, kidney problems and whooping cough are treated with the tree's leaves and bark, prepared in tea or applied as a paste.[1]

1. Anonymous. 'Copal.' *Atlas de las plantas de la medicina tradicional.* UNAM. May 27, 2013. Accessed on the Web, Jan. 11, 2013.

EL COSTUMBRE

El costumbre is a term shared by indigenous peoples in the Huasteca referring to an immense body of ritual practices, not to be confused with the feminine *una costumbre* meaning 'a custom'. Important elements of *el costumbre* are music, food, dance, prayers and sacrificial paper images. Sacred songs called *sones de costumbre* are played with violin and *quinta huapanguera* to summon the gods. Food is prepared to properly receive the divinities, and dance is performed as an offering.

One of the most elaborate *costumbres* is a complex ritual dedicated to Chikomexochitl, the corn god. It is celebrated by Nahuas in Ixhuatlán de Madero, a municipality in northern Veracruz. The whole ritual cycle comprises five stages of the plant's development, from planting to after the harvest. A specific instrumental *son* is played during each stage of the ceremony. For example: a *son* for cutting the paper, a *son* for making an offering to the earth and a *son* for planting the corn.[1] Another elaborate *costumbre* is Atlatlacualtiliztli (the act of feeding the rain), which is dedicated to the gods associated with rainfall.[2]

1. Nava Vite, Rafael. 'El costumbre: ofrendas y música a Chikomexochitl en Ixhuatlán de Madero, Veracruz.' *Revista EntreVerAndo*. Veracruz: Universidad Veracruzana Intercultural, October, 2009. 44–46. Accessed on the Web, Jan. 14, 2014.

2. Gómez Mart[inez, Arturo, and Anuschka van't Hooft. 'Atlatlacualtiliztl']i: la petición de lluvia en Ichcacuatitla, Chicontepec.' *Lengua y cultura nahua de la Huasteca*. Prod. Anuschka van't Hooft. Mexico D.F.: CCSYH-UASLP/Linguapax/ CIGA-UNAM, 2012. DVD Multimedia.

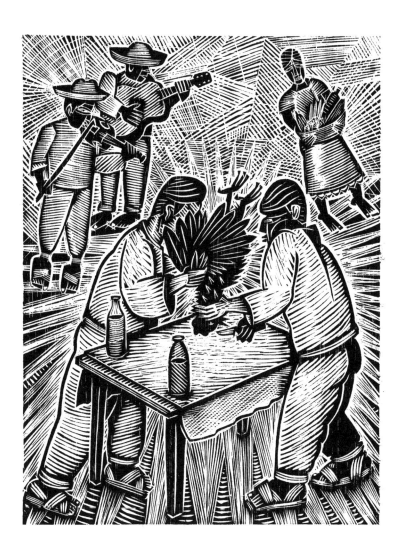

EL COTORRO

Yellow-headed parrots (*Amazona ochrocephala*) once frolicked in the Huasteca's lush forests, painting the sky with furtive emerald clouds. Severe deforestation has since reduced their habitat, and they have been indiscriminately captured for sale as colourful household pets, so it is rare to hear their flirtatious banter in the wild. Nowadays they are more likely to appear as embroidered motifs on festive clothing worn by dancers at a *huapango*. The *rabel*, a bowed instrument descended from the medieval rebec, is associated with the parrot due to its shrill tone and the scroll of the instrument is sometimes carved to resemble the head of the noisy bird. The rebec may have entered Europe with the Moorish conquest of Spain.

El cotorro appears in a Tepehua deluge myth collected by Roberto Williams García. Long ago, when the world was besieged by yearly floods a man decided to save himself by building a wooden box to use as a raft. Once the flooding began he got into the box and a parrot hopped on top. The box floated on the rising water until the parrot hit his head unexpectedly on the 'ceiling' of the sky and cried out in pain. Since then, parrots can only walk by bending forward towards the ground.[1]

1. Williams García, Roberto. *Mitos tepehuas*. Mexico: Secretaría de Educación Pública, 1972. 79.

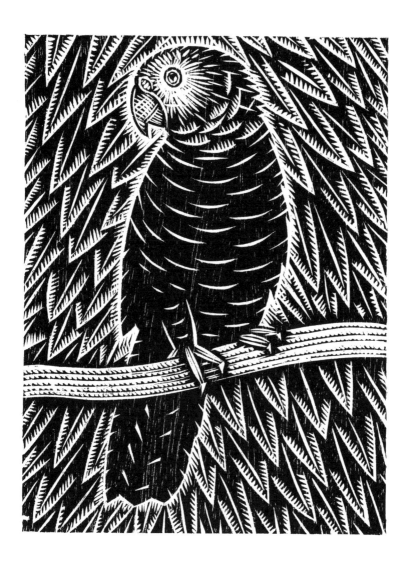

EL CUARTILLO

The *cuartillo* refers to a set of wooden boxes of varying sizes used to measure dry goods. The practice originated in Spain and is still common in the Huasteca. Today, they can be seen there, resting on mounds of corn being sold at weekly open-air markets called *plazas*. The standard *cuartillo* contains about three and a half kilos of corn. Smaller boxes as well as metal cylinders are used for measuring beans and chili peppers. The average Mexican consumes about sixty-nine *cuartillos* of corn a year.[1]

Nahua healers make use of the *cuartillo* during divination ceremonies in their homes. One of the boxes is overturned and placed on the floor with a white cloth covering it. After making the sign of the cross the healer proceeds to toss fourteen grains of corn on the flat surface of the cloth. The pattern made by the scattered corn is then scrutinized for symbolic messages. If necessary the process is repeated until a satisfactory conclusion has been reached. The patient and family are then informed as to the cause of the illness and told what steps should be taken.[2]

Don Goyo Melo, a charismatic *huapanguero* and instrument builder born in 1926, is famous for using the *cuartillo* as a miniature dance platform.

1. Güemes Jiménez, Román. *Cultura desocupada.* Veracruz: IVEC, 2005. 49.

2. Barón Larios, José. *Tradiciones, cuentos, ritos, y creencias Nahuas.* Pachuca: Consejo Estatal para la Cultura y las Artes de Hidalgo, 1994. 74–75.

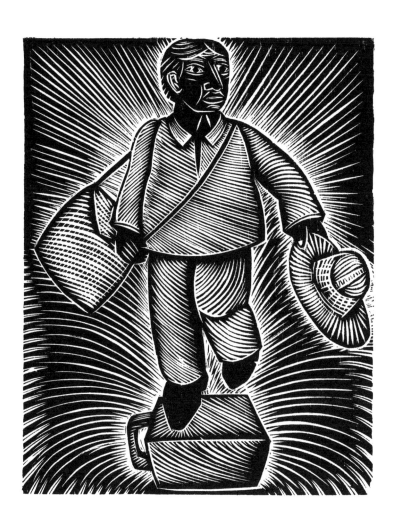

LA CUERA

The northern edge of the Huasteca stretches across southern Tamaulipas, a mainly arid state with vast areas devoted to raising livestock. Inland from the Gulf Coast, tropical vegetation soon gives way to cacti, thorny mesquite trees and grazing cattle. This is where vaqueros once wore long protective suede coats called *cotónes*, made from deer hide. Legend has it that during the Mexican Revolution General Alberto Carrera Torres fancied adding fringes and decorative motifs to the frugal *cotónes* used by his men. Rosalio Reyna, a soldier and tailor from the town of Tula in Tamaulipas, inspired by the local flora, applied the now emblematic designs by sewing them on in suede of contrasting colours. Since then, the popularity of the *cuera* has spread throughout the Huasteca, and today Reyna's family continues to make them in his hometown.

Dr Norberto Treviño Zapata, former governor of Tamaulipas, contributed to the popularity of the *cuera* throughout the Huasteca by designating it as a regional costume. What was once a rugged garment worn exclusively by vaqueros has become a costly one used on special occasions by both men and women, and worn with pride by many *son huasteco* musicians.

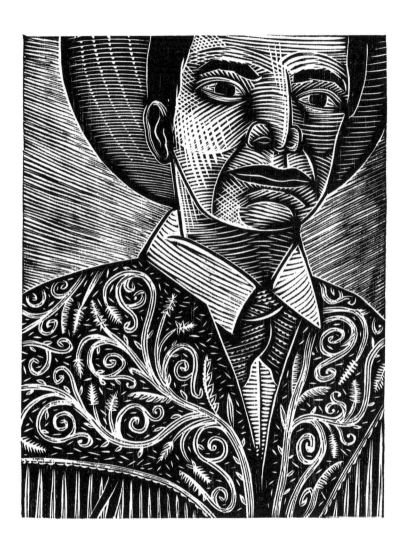

LA CURANDERA

There are many different kinds of healers, or *curanderas*, in the Huasteca: soothsayers, witches, bonesetters, herbalists and midwives. They usually combine an ancestral understanding of the properties of plants with their role as intermediaries between humans and the gods. It is generally believed that a malady occurs when the delicate balance of forces existing within a person has been altered.[1] This can happen when someone's soul has been dislodged or lost, and harmful external forces can also enter the body in the form of spirits such as Ehécatl, meaning 'wind' in Nahuatl. Healers are trusted to identify the cause of the affliction and to help restore balance in the person. A variety of techniques may be used in the diagnosis, such as touch, observation and dream consultation. Divination using kernels of corn is another method, mentioned in the description of *el cuartillo*. Music and dance are also therapeutic agents. Treatment usually involves a ritual purification in the home of the practitioner, and ceremonial offerings are also customary in sacred places such as caves, mountains or streams. Respected healers are said to be born with a special talent and significant experiences during childhood may indicate that someone is destined to cure.

1. Gallardo Arias, Patricia. 'Los especialistas de la curación. Curanderos teenek y nahuas de Aquismón.' *Anales de Antropología*. Mexico: UNAM, Vol. 38, 2004. 183.

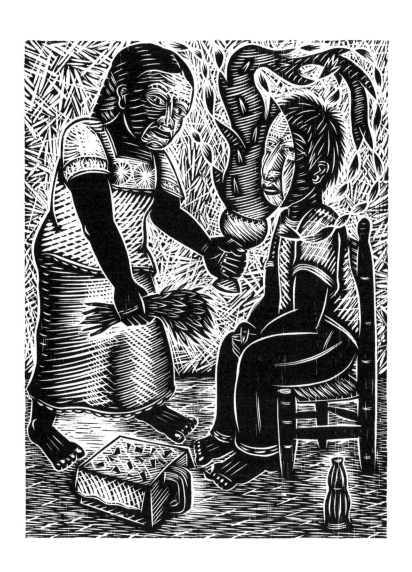

LA DANZA

For thousands of years dance has been part of the milieu and mythology of this prodigious region. While the recreational *huapango* is popular among a large cross-section of the population, an astounding diversity of dance forms also exists within the ritual context. Ceremonial dance is part of complex rites involving fasting, specific food, prayers, sacred music and private ceremonies. Being a dancer in festivities such as carnival often requires a commitment lasting several years under the guidance of a spiritual leader. Many agricultural rites honour the corn plant through dance. For example, in the state of San Luis Potosí the *tzacam son* ('little dance') is part of a cycle that marks important stages in the growth of corn. Prior to planting, the grain is awoken with a dance; later a 'new corn' ceremony precedes the harvest; and finally there is a ceremony 'for the earth to rest'. *Tzacam son* is dedicated to both Dhipak, the corn god, and Saint Cecilia, the patroness of musicians.[1] (An example of the way in which Catholicism and beliefs with pre-Columbian origins are intertwined in the Huasteca.) Since the precious grain is susceptible to unpredictable extremes of nature such as drought and torrential rains, many dances are intended to mitigate these forces. In other celebrations, carnival for example, the dancers use masks to represent spirits and mythological beings.

1. García Franco, Marco. 'Tzacam son. Tampate, Aquismón.' *Cuerpos de maíz: Danzas agrícolas de la Huasteca.* Mexico D.F.: Programa de Desarrollo Cultural de la Huasteca, 2000. 91–92.

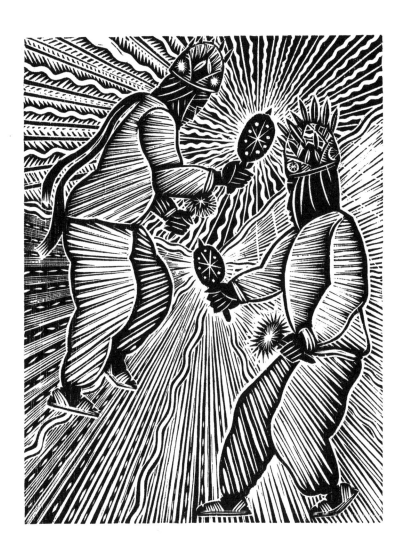

EL GALLO

The rooster is a ubiquitous bird in the rites, myths, iconography and music of the Huasteca. Since being introduced to Mexico in the fifteenth century it has been integrated into a variety of agricultural and healing rituals. In La Esperanza, a small community in the municipality of Tantoyuca, Veracruz, a Nahua healing ceremony requires a rooster for the preparation of ritual food (*tlaixpantia*). To begin, the healer 'brushes' the afflicted person from head to toe with a live rooster and a chicken as part of a ritual cleansing. The fowl, which must be free-range animals, are then sacrificed by the healer and prepared in separate tamales. These and other items, including cookies, bread, sweets, water and coffee, are taken to the *ofrenda* assembled at a special shady place in the countryside associated with the Tepas.

The Tepas are inhabitants of the underworld who fled there to escape the sun. Associated with illness, the Tepas are offered food in exchange for the return of the patient's well-being. Both tamales are positioned so that the portion containing the fowl's head points east, to ask the sun for strength.[1]

1. Ariel de Vidas, Anath. 'Nutriendo la sociabilidad en los mundos nahuas y teenek (Huasteca veracruzana).' http://comidaritual.wordpress.com. Jan. 1, 2013. 7–8. Accessed on the Web, Jan. 14, 2014.

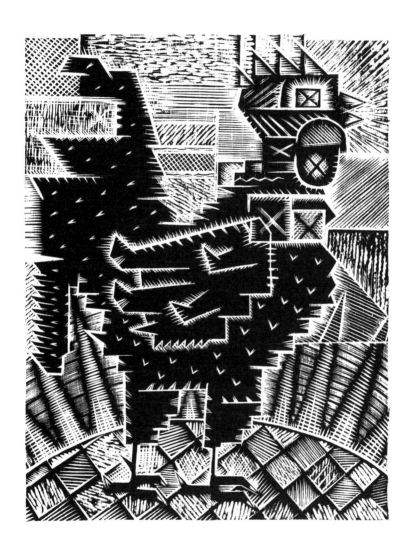

EL GUAJE

The word *guaje*, from the Nahuatl *huaxin*, refers to two distinct plants in Mexico. One is an acacia tree found in the Huasteca, whose long pods contain edible seeds that are eaten raw, toasted or ground into a sauce called *guaxmole*. Over a thousand species of this tree exist around the world. One of three disputed meanings of *huasteco*, from the Nahuatl *cuexteca*, is 'territory abundant in *huaxin* trees'.[1]

A *guaje* is also a vine bearing a large and very useful squash. When dried and hollowed out, the lightweight and resilient gourd becomes an ideal receptacle for transporting water. It also appears in popular sayings such as *'Hacerse guaje'* 'to be like a gourd', which means 'to play dumb'. Another saying, *'El que nació para guaje de acocote no para'*, means, literally, 'someone born to be a *guaje* is bound to become an *acocote'*. An *acocote* is a gourd used as a tool to siphon sap from the maguey plant, which is then fermented to make *pulque* or distilled spirits such as tequila and mezcal. In northern Spain *guaje* means a child or apprentice. Its origin is unclear, but it once referred to children who worked in the mines.

1. Güemes Jiménez, Román. Introducción. *La Huasteca: una aproximación histórica*. Mexico D.F.: Programa de Desarrollo Cultural de la Huasteca, 2003. 11.

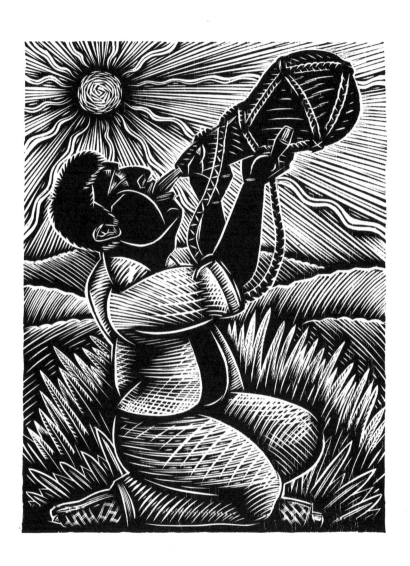

EL HORNO

Mexican bakeries are excellent places in which to marvel at local humour and regional diversity. Astonishing as the variety of pastries displayed in every bakery are the creative names given to them: babies' bottoms, underpants, nun's tits, mule's eyes, neckties, volcanoes, kisses, knots, flutes, drunks, devils and fans are just a few. As night falls in smaller towns and villages, vendors roam the streets carrying baked goods in large baskets, some of which are designed to be worn like hats. Bakeries rely on these salespeople to drum up business.

In rural Huasteca, families that make bread for a living bake with a special oven (*horno*) also used to make *zacahuil*. Built on a stone base about a metre high, the *horno* is made of a dense combination of mud, grass and stones in a dome supported by a large armature of branches. In Veracruz state, the towns of Chicontepec, Colatlán and Tantoyuca are well known for their bread. In Hidalgo state, Orizatlán and Huejutla have a reputation for good bakers. Particularly delicious are the pastries containing cheese mixed with cinnamon and *piloncillo* (unrefined sugar).

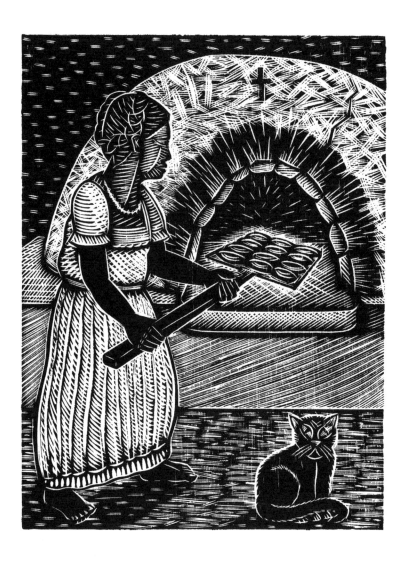

EL HUAPANGO

On both sides of the *tarango* (a wooden scaffolding on which musicians perform) large speakers amplify the propulsive melodies of the violin along with the pulsating beat of *jarana* and *huapanguera*. To complete the rhythm section, a mass of couples synchronize their percussive stomping while moving freely across a grid of plywood risers. Such large-scale events, called *huapangos*, are an indication of the healthy popularity of the region's traditional music. In essence, a *huapango* is any celebration that is animated by *son huasteco* and includes the participation of dancers. Impromptu *huapangos* do not require special installations: a *trio huasteco* and a few couples dancing are sufficient.

One theory suggests that *huapango* comes from *cuahpanco*, a Nahuatl word comprised of *cuahuitl* ('wood'), *pan* ('on top of') and *co*, which denotes a physical location. Or, it might be a local adaptation of the word *fandango*. A *huapango* is also a type of popular song that emerged in the 1940s, based on the syncopated lilt of *son huasteco*. Some famous *huapangos* composed in the twentieth century are 'Serenata huasteca' and 'Las tres huastecas'. They should be distinguished from *sones huastecos*, which are anonymous compositions allowing for the introduction of new verses and poetic improvisation. A *huapango* song has specific lyrics that are not subject to alteration.

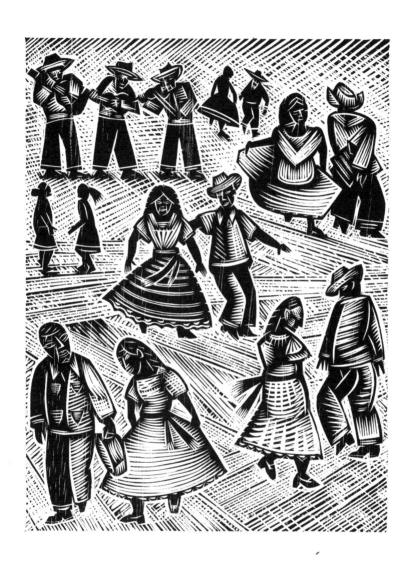

LOS HUARACHES

Handcrafted shoes akin to sandals are referred to as *huaraches* all over Mexico. The word comes from the state of Michoacán, where *kuarachi* means 'sandal' in the Purépecha language. Usually the leather upper is made of strips of leather woven together with varying degrees of complexity. In the past they were synonymous with rural poverty but now *huaraches* have become standard footwear in both the city and the countryside. Hundreds of models can be found, ranging from roughly hewn pieces of old car tire fastened with crude leather straps to intricately woven examples of sophisticated Mexican craftsmanship. An inexpensive unwoven type of Huastecan *huarache* with thick leather straps is still made in Ahuacatlán de Guadalupe in Querétaro and in Jaltocán in Hidalgo. Jalisco, Michoacán and Oaxaca are the states in which to find exquisite *huaraches* that have inspired a number of high-end designers such as Ralph Lauren and Proenza Schouler.

Several Mexican sayings refer to *huaraches*. For example: '*No da paso sin huarache*', which, translated literally, means, 'Doesn't take a step without a sandal.' This refers to someone who won't make any decision or take any action unless he or she feels safe or protected while doing it. Another saying, '*No porque me vean huaraches piensen que soy huacalero*' translates as 'Just because I wear sandals don't assume I am a *huacalero*.' A *huacalero* is someone who earns a living carting around crates in a market.

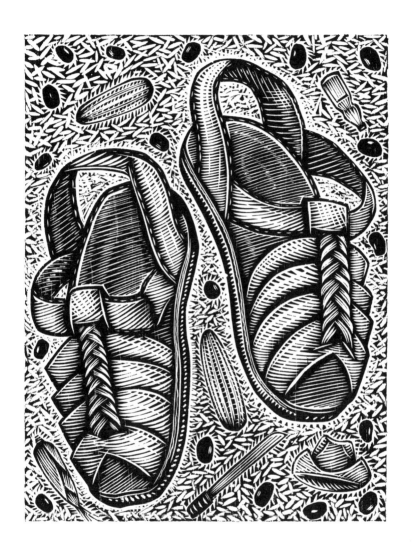

LA JARANA HUASTECA

Son huasteco ensembles conform to a strict format of a violin, a *quinta huapanguera* and a *jarana huasteca*. The *jarana* is similar in size and shape to the baritone ukulele but has five strings instead of four and is tuned in thirds. Initially the *jarana* was not used to play *sones huastecos*. About a hundred years ago, however, the *jarana* was adopted to provide additional rhythmic flourish and a broader sonority. In tandem with the much larger *quinta*, a tight musical accompaniment is maintained against which the violinist's fantasies unfold, couples dance and singers improvise. Despite the national popularity of certain *sones huastecos* like 'El Querreque' and many new compositions based on the traditional *huapango* rhythm, the *jarana* is rarely used outside the traditional trio. The standard guitar is used in its place.

There is no consensus as to the origin of the word *jarana*, which has varied meanings throughout Latin America. In the Yucatan, for instance, it is a dance form and musical genre played by small orchestras, while in Peru it is a festive occasion. *Jarana* can also mean 'a brawl', or 'a scam'. In Nicaragua, *una jarana* is 'a debt', while in Cuba it means 'a party' or 'to joke around'.

EL MAPACHE

Mapache is the Mexican word for 'raccoon', borrowed from the Nahuatl *mapachtli*. The word *mapachtli* comes from *maitl*, 'hand' and *pachoa*, 'to squeeze something'. By extension, it means 'thief' (*mapachoa* means 'to steal') and raccoons were called that because they would steal food from people.[1] In late September, when the corn plants are nearing maturity, these animals are attracted to the ripe cobs, as are squirrels, deer, wild boar and skunks. Keeping them at bay is an arduous task involving the entire community.

In Los Ajos, a village in the municipality of Tantoyuca, Veracruz, a celebration called *mapachi iljuitl*, 'the mapache's party', reaffirms the combined effort required to ensure a healthy and abundant crop. It takes place in late September or early October, in a large communal space built for meetings and social gatherings called a *galera*. During the ceremony, community members are chosen to assume specific roles. Children represent the pilfering raccoons, and adolescents act the part of hunting dogs. Adults assume the roles of hunters, a married couple and their *compadres*. Corn plants are assembled to represent the crop, and a special altar is also built for the ceremony.[2]

1. Karttunen, Frances. *An Analytical Dictionary of Nahuatl.* Norman: University of Oklahoma Press, 1992. 137.
2. Argüelles Santiago, Jasmín Nallely. *El maíz en la identidad cultural de la Huasteca veracruzana.* La Paz: Plural Editores, 2010. 149–50.

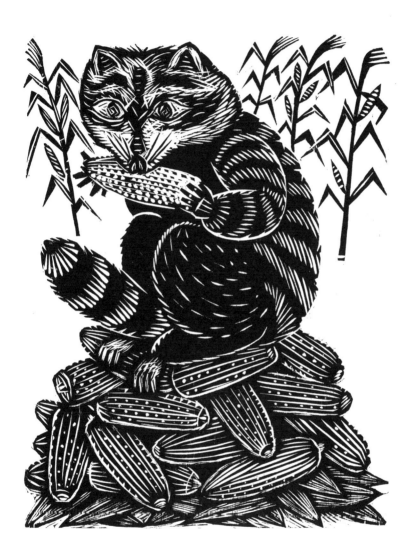

EL METATE

For thousands of years this palette has been used to mix chilies and other spices into *adobos, moles* and *salsas*. A piece of carved volcanic stone used as a grinding surface, the *metate* (from the Nahuatl word *metatl*) is used in conjunction with the *metlapil*, a cylindrical tool, also known as a *mano* ('hand' in Spanish). The *metlapil* is scraped back and forth along the stone surface measuring between thirty and forty centimetres. Most *metates* have three stubby legs but *metates* without legs, called *huilanches*, are common in some areas.[1].

Archaeological evidence from Mexico, Belize, Guatemala and Costa Rica shows that grains, spices, pigments and medicinal plants were pulverized this way all over Mesoamerica. Their abundance at burial sites and in the foundations of ceremonial buildings implies a ritual use for the *metate*, and perhaps an association with the transformative passage from the world of the living to another realm of existence.[2]

With the invention of the blender and specialized machines used to grind corn, the *metate* has disappeared from many households. Time and exertion are saved by taking corn to a local mill for grinding into *masa* ('dough') and chilies can be tossed into a blender along with tomatoes for a quick salsa. Nevertheless, *metates* are still in use throughout the region and are easily obtained in Huejutla, Hidalgo's large weekly market.

1. Güemes Jiménez, Román. *Hoy le canto a mi sustento: Romance para el sabor de la mesa huasteca*. Xalapa: Universidad Veracruzana, 2013. 74. Accessed on the Web, Nov. 10, 2013.
2. Toby Evans, Susan, and David L. Webster. 'Ground Stone Tools.' *Archaeology of Ancient Mexico and Central America: An Encyclopedia*. London: Routledge, 2009.

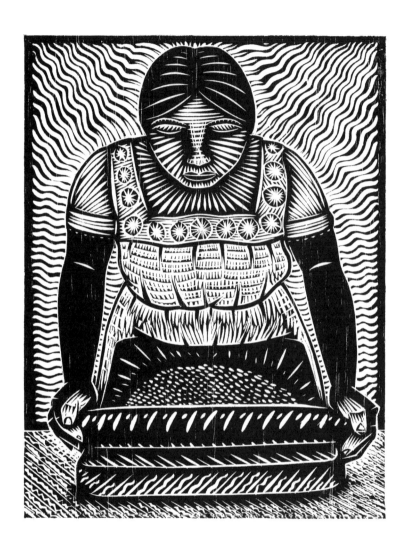

LA MILPA

The word *milpa* combines the Nahuatl *milli* ('sown plot') with *pan* ('on') to designate the precious terrain at the core of complex mythologies and agricultural rituals. Also meaning 'a cultivated field', *la milpa* is a Mesoamerican agricultural system based on the combination of corn with other crops such as beans and squash. Pumpkin, chilies, chayote, cassava and citrus fruits can also be found within the perimeter of the *milpa*. Each plant is grown according to a well-defined agricultural calendar intimately connected to a corresponding series of festivities. Two such rituals, performed by Nahuas in the state of Veracruz, are *sintlamana* ('the presentation of the seeds') and *elotlamanalistli* ('the offering of the cobs'). *Sintlamana* is a household ceremony that takes place the day before planting, requiring a basket of the selected seeds to be placed before a small altar. *Elotlamanalistli* celebrates the new corn that is brought home from the *milpa*. A few tender cobs are selected for the ceremony; they are then decorated with flowers and children carry them through the door. A special arch is built for the children to walk under.[1] For the Nahuas the corn plant is synonymous with Chikomexochitl, the anthropomorphous corn god who provides the community with food and cares for all the other plants. The Teenek refer to him as Dhipak.

1. Argüelles Santiago, Jasmín Nallely. *El maiz en la identidad cultural de la Huasteca veracruzana*. La Paz: Plural Editores, 2010. 156.

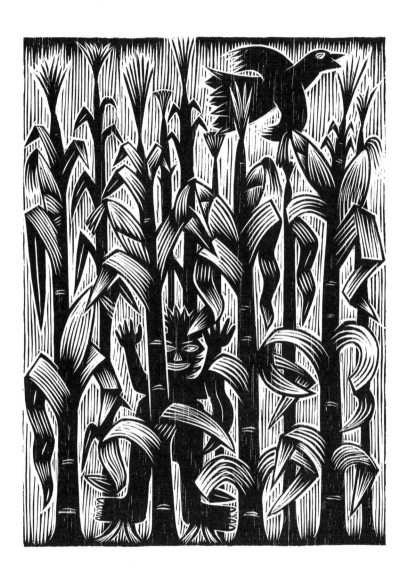

EL MORRAL

Originally a *morral* was a satchel used by hunters in Spain to carry provisions. Nowadays the word is used in Latin America for all kinds of shoulder bags. In Mexico, specific models are associated with the indigenous peoples who make and use them. Like *huaraches*, their decorative appeal and resilience have made them popular among both the general population and tourists.

El morral tantoyuquero, unique to the municipality of Tantoyuca, Veracruz, is woven by Teenek men and women using *zapupe* fibres on a backstrap loom. *Zapupe*, a local agave plant, is not exploited on a large scale although some attempts were made to do so in the states of Veracruz and Tamaulipas around 1910.[1] Extracting the fibres from the plant is a painstaking process that requires scraping the long stalks. Once the individual fibres are separated they are then left to dry for several days before being 'combed' into the raw material weavers use on the loom. As a final touch, the plain surface is stamped repeatedly with a four-petal floral motif. During Xantolo, a *morral* containing items a deceased farmer once took with him to the field may be placed on the *ofrenda* to remember and honour him.

1. Hoxie Dewie, Lyster. *Fiber Production in the Western Hemisphere.* Washington, D.C.: United States Department of Agriculture, August 1943. 21–22.

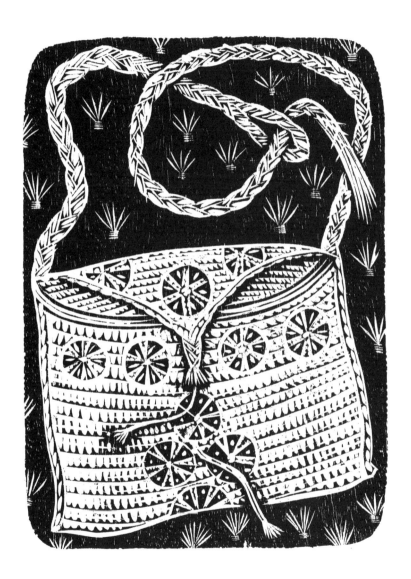

EL NUKUB

El nukub, a cylindrical slit drum hollowed out of a tree trunk, is more commonly known by its Aztec name, *teponaztle*. To make a *nukub*, three incisions are carved into the trunk to create a pair of tongues, tuned to different pitches. At the time of the Spanish conquest of Mexico its use was widespread among the Aztec and Mayan peoples who venerated the instrument as a god.

A handful of communities in the states of Chiapas, Morelos and Veracruz still have a ceremonial use for it. This illustration refers to *la danza del tigrillo* ('the tiger cat dance'), which is unique to a few Teenek villages in the municipality of Tantoyuca, Veracruz. The ceremony is a representation of the myth of a witch who, transformed into a tiger, caused terrible havoc but was eventually defeated by the community. While one musician plays the *nukub*, another man plays a small reed flute and a couple of men wearing cloth feline masks dance and pretend to attack the players. The ritual is performed on important religious holidays such as the celebration of Santiago Apostol in July and the celebration of La Virgen de Guadalupe in September.[1]

1. Ariel de Vidas, Anath. *El trueno ya no vive aquí. Representación de la marginalidad y construcción de la identidad teenek (Huasteca veracruzana, México)*. Mexico: col. Huasteca, ciesas-Colegio de San Luis-Centro Francés de Estudios Mexicanos y Centroamericanos-Instituto de Investigación para el Desarrollo, 2002. 456–57.

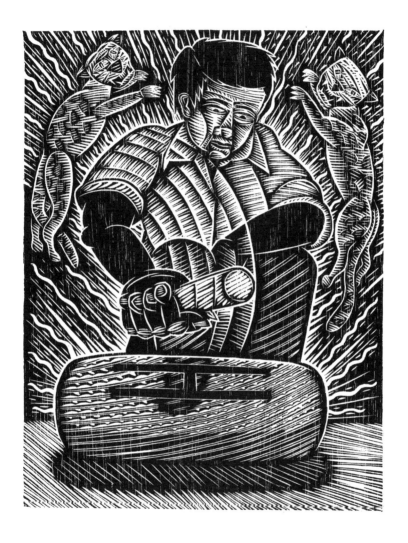

LA OFRENDA

Small domestic altars are a permanent fixture in many Mexican homes whereas large temporary structures, like the one portrayed here, are built just before October 31, when the souls of the deceased are received by their relatives during several days of celebration. *Ofrenda*, which means 'offering', refers to the food and other items such as flowers, candles and incense that are carefully arranged on a table for the souls of returning ancestors. Additional levels in the form of steps are assembled on the table to represent the stages the soul passes through in the afterlife. The installation is also called an *arco*, for the arch built over the table to create a symbolic gateway through which the souls pass.

Great care and expense go into the *ofrenda*, and some people believe that the welcome must be generous, otherwise misfortune may befall the household. The tradition within which the *ofrenda* is carried out, commonly known as the Day of the Dead, is referred to as 'Xantolo' in the Huasteca. 'Xantolo' is a local adaptation of the word 'Sanctorum', from the Latin for 'All Saints' Day' (Festum Omnium Sanctorum). A spiritual occasion when people are reunited with their ancestors, it is also a time for family and friends to socialize and share a meal. The special dishes on display are enjoyed by the extended family and visiting friends.

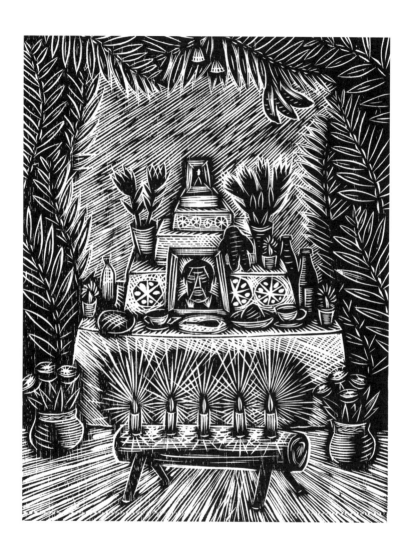

EL PETOB

The *petob* is an elaborate 'crown' worn by Teenek women from the state of San Luis Potosí. They create it by weaving yarn of different colours into their long hair. The large circular headwear was once made using flexible liana that grows near riverbanks but has since been replaced by yarn. The size of the adornment varies, but married women tend to create a larger *petob* than girls and adolescents, who are more discreet. Several different colours are used symbolically to indicate a woman's marital status: green and pink for single women; married women add red and orange; and widows are free to use any combination of colours they wish.[1]

Today's wearing of the *petob* continues an ancient tradition that goes back at least a thousand years. A magnificent pre-Columbian example of the *petob* is the *Diosa de Coatepec Harinas*, a rare wooden sculpture of a female deity from the late post-classic period (AD 1200–1521), found in a cave in the Toluca Valley.

1. Gallardo Arias, Patricia. *Huastecos de San Luis Potosí*. Mexico: CDI, 2004. 6.

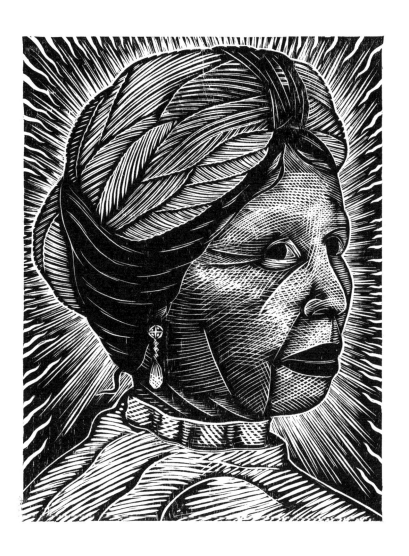

LA PLAZA

Día de plaza, 'market day' in Spanish, is the occasion when itinerant merchants transform town squares with an array of local produce and imported goods. Elsewhere in Mexico, these markets are called *tianguis*, borrowed from *tianquiztli*, a Nahuatl word also meaning 'the Pleiades'. In ancient Mexico a stroll through the market was called *tlanquiztlayaualoa*.[1] The legendary *plaza* in Huejutla, a small town in the state of Hidalgo, has been a major commercial gathering place for centuries. Smaller markets are held on alternate days in surrounding communities.

During the week, merchants travel from *plaza* to *plaza* selling food, electronic devices, plastic knick-knackery and even imported second-hand clothing. A meandering walk among the vendors is an opportunity to experience local diversity, and the multicultural character of the market can be heard in the concert of indigenous languages and Spanish as people barter for live turkeys, fresh bread, *zacahuil*, pottery, candles and *copal*. Fresh produce is carefully displayed on woven palm mats called *petates* and on tables of all sizes. Herbal remedies are also on offer along with handmade cooking utensils and traditional delicacies.

1. Robles Álvarez, Irizelma. 'Del tianquiztli a las plazas.' *Focus III*. Bayamón: 2004. 67. Accessed on the Web Jan. 16, 2014.

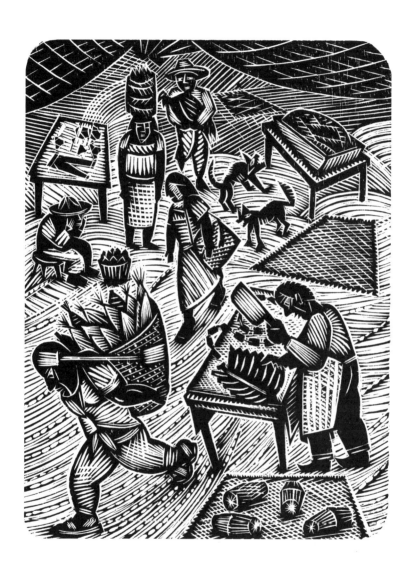

EL QUECHQUÉMITL

This garment, consisting of two rectangular pieces of cloth that are sewn together and embroidered, is worn by indigenous women in various parts of Mexico. The most ornate examples are found in a few Nahua and Teenek communities of the Huasteca. While the Nahua call it a *quechquémitl*, a word comprised of *quechtli* ('neck') and *quemitl* ('garment'), the Teenek call it *thayemlaab*, meaning, simply, 'garment'. The ample surface is embellished with religious iconography, traditionally passed down from mother to daughter.

The elderly Nahua woman depicted here has a tree of life symbol, a cross indicating the cardinal directions, flowers and mythological animals embroidered on her *quechquémitl*. On the Teenek *thayemlaab* the central motif is an eight-pointed star or flower, representing Dhipak, the corn god.[1] Numerous ceramics of female deities wearing the *quechquémitl* have been discovered by archaeologists, such as an early example, dating from the late third century AD, found in Xochitécatl, an archaeological site in Tlaxcala state. Also depicted wearing a *quechquémitl*, in the Codex Borgia, is Mayahuel, a goddess of fertility associated with the maguey plant. Little is known about the kind of motifs that may have been applied to this pre-Columbian clothing because the oldest surviving examples date only from the early nineteenth century.

1. Rocha Valverde, Claudia. 'Quechquémitl y thayemlaab. Tradición textil en la Huasteca potosina.' *Lengua y cultura nahua de la Huasteca*. Prod. Anuschka van't Hooft, Mexico D.F.: CCSYH-UASLP/Linguapax/CIGA-UNAM, 2012. 3. DVD Multimedia.

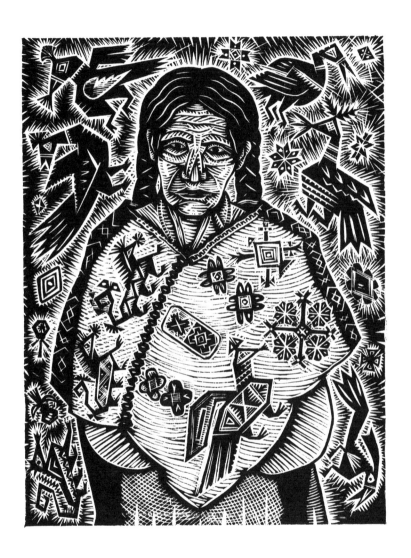

EL QUERREQUE

Querreque, a local name for the woodpecker, is an onomatopoeia for the percussive sound produced by the bird when it hammers into tree trunks. It is also a particularly festive *son huasteco,* popular for its comic verses and a catchy chorus during which 'Querreque!' is repeated four times. Pedro Rosa Acuña, the legendary violinist from Xilitla, a municipality in San Luis Potosí, was the first to record it, in 1957. Since then it has become the most requested *son* in the repertoire. Although his name is associated with *el querreque,* there is some controversy as to whether Pedro Rosa Acuña is the composer. Many other groups, such as Trio Chicontepec, have recorded influential versions with original lyrics.

As is the case with all traditional *sones huastecos,* there is no definitive version. Drinking is a theme of some well-known *querreque* verses but it is also a popular vehicle for improvisation and a sponge for new lyrics. During its performance, someone in the audience may become the target of humorous poetic improv. In this case sexual innuendo is the habitual form of mockery. While most spontaneous poetic outbursts are short-lived, some survive to become popular verses in the repertoire.

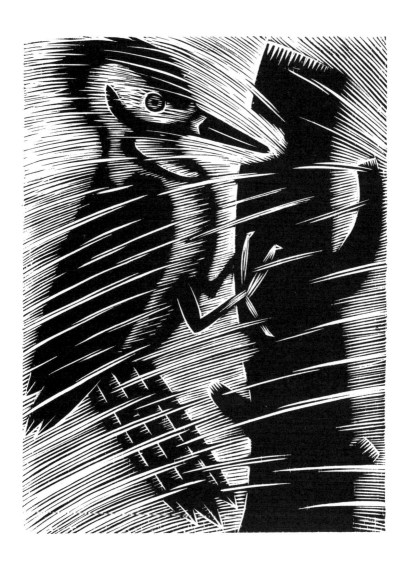

LA QUINTA HUAPANGUERA

This instrument is unique to the region and is associated primarily with *son huasteco*, the thriving musical genre that has evolved within indigenous and mestizo communities. While similar in construction to a guitar, the body is twice as deep, providing its characteristic bass register and portly appearance. Unlike the guitar, the fretboard is flush with the top to facilitate a repetitive muting of the strings. *Huapango* dancers are guided by the thumping bass that this strumming method produces. Skilled *quinta* players interrupt the rhythm with short solos, providing playful counterpoint to the violin's melodic lead.

Like other Mexican strummed instruments, the *quinta* has roots in the sixteenth and seventeenth centuries, when the *vihuela* and the Spanish guitar were brought to Mexico. These European 'guitars' acquired distinctive regional characteristics as specific genres of *son* developed all over Mexico. For example, the *guitarra de son* and *jarana jarocha* in southern Veracruz, the *guitarra de golpe* in Jalisco and the *bajo quinto* in Morelos. It is also used in *son de costumbre*, a repertoire of hundreds of instrumental pieces for violin and *quinta huapanguera*. The music in this context has a sacred and ceremonial function.

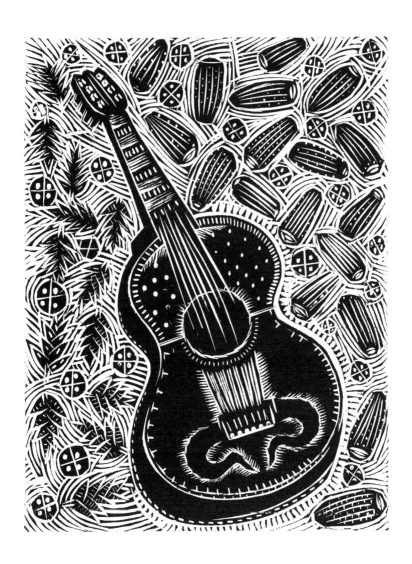

EL RABEL

The long journey of the *rabel* as a popular folk instrument is difficult to trace with precision. Early records of this ancient chordophone date back to the mid-sixteenth century and one possible ancestor is the Arab *rabâb*, which entered Spain with the Moors. Similar instruments are abundant in European medieval iconography although they often differ from the *rabel* as played today.[1] From Europe it travelled throughout Latin America with Spanish colonization, and was integrated into a number of regional musical traditions.

In South America the Chilean island of Chiloé is associated with the *rabel*, as were certain parts of Panama. In Mexico it is still played in a few Nahua communities in San Luis Potosí, where it is called *cuachele*. There it is used as a sacred instrument in agricultural ceremonies and Xantolo rituals. The ability to play the *cuachele* is considered a divine gift and some musicians describe how they learned the musical repertoire in their dreams.[2] In Nahua mythology 'small thunder gods' play the *rabel* to please the god of water.[3] Today its stronghold is in Spain, in the provinces of Cantabria, León and Asturias, where documentation of older players and recent enthusiasm have helped bring the *rabel* back to the fore.

1. Sánchez Bueno, Soledad. *El rabel medieval en España.* 2004. 7. Accessed on the Web, Dec. 1, 2013.
2. Camacho Díaz, Gonzalo. 'Dones devueltos: Música y comida ritual en la Huasteca.' *Itinerarios.* Vol. 12. Varsovia: 2008: 74. Accessed on the Web, Jan. 16, 2014.
3. Tiedje, Kristina, and Gonzalo Camacho Díaz. 'La música de arpa entre los nahuas: simbolismo y aspectos performativos.' *Lengua y cultura nahua de la Huasteca.* Prod. Anuschka van't Hooft, Mexico D.F.: CCSYH-UASLP/Linguapax/CIGA-UNAM, 2012. 5. DVD Multimedia.

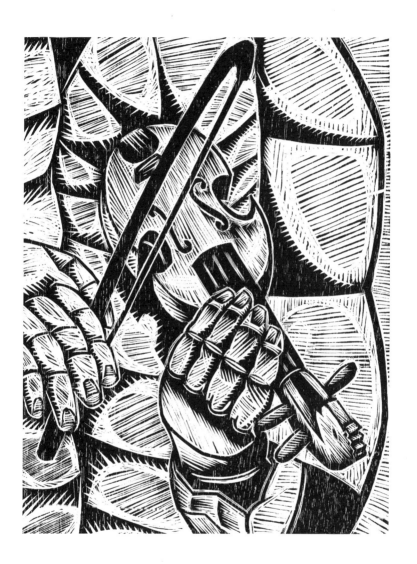

LA SIEMBRA

La siembra refers to the time when corn is sown, which in the Huasteca occurs twice a year. The first *siembra*, coinciding with the start of the dry season in December, is called *tonalmilli*. *Ipoualpan* is the second *siembra*, and coincides with the rainy season, beginning in late May or early June. As with other stages of the agricultural cycle, *la siembra* is a highly ritualized event. The Nahuas of Chicontepec, Veracruz, practise a ritual called *xinachtlacualtiliztli* 'offering to the seed', which precedes the planting of corn and beans. A similar ceremony practised in Tepetzintla, Veracruz, is called *sintlamana*. Both involve asking the earth for permission, so that the plants may reach fruition and be spared the ravages of plagues and rodents.

Initially the seeds are placed on the family altar, bathed in incense and given offerings of *aguardiente*, soft drinks and food. These items are then taken to the field where prayers are said to the earth and to the gods entrusted with protecting the plants. A wooden cross, decorated with garlands and marigolds, is erected in the middle of the field, and a token tribute of the food and drink is deposited at each of the four corners of the terrain. The inclusion of elements such as the cross and the saying of Catholic prayers is part of a complex process originating during the colonial period. Religious repression, centuries of Christian dominance and reinterpretation of Christianity have contributed to the indigenous world view.[1]

1. Gómez Martínez, Arturo. *Tlaneltokilli: la espiritualidad de los nahuas chicontepecanos*. Mexico: Ediciones del Programa de Desarrollo Cultural de la Huasteca, 2002. 115.

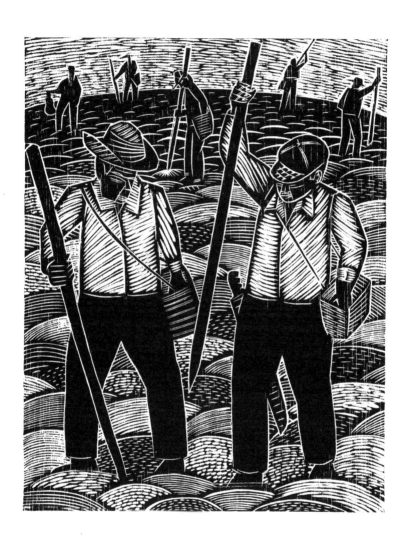

LA SIRENA

The venerable *sirena*, 'mermaid', is a deity associated with water and fertility. Her bad temper, blamed for the destructive forces of hurricanes and floods, is placated with offerings intended to ensure the best climatic conditions for a bountiful crop. In Nahuatl she is called Apanchanej, a name that means 'female water dweller', and though she does not lure sailors off course with an enchanting song, perilous whirlpools created by her sinuous hair are blamed for deaths in rivers and at sea.[1]

One myth explains how she was born from thunder and lightning in the ancient volcano called Postectli, a sacred mountain located in the municipality of Chicontepec, Veracruz. Various stories about her mention a prehistoric era inhabited by a few humans whom she taught to farm. On one occasion they spied her bathing, and were appalled to see how she produced the fish and salt she gave them to eat by rubbing her skin. Out of anger, they forced her into exile near the coastal town of Tuxpan, where she was protected by a number of gods, including Ehecatl (the wind). In revenge, Apanchanej punished her persecutors with death by drowning, drought and diseases such as measles and chicken pox. *La sirena* belongs to a pantheon of Nahua water deities that includes Meztli (the moon), Mixtli (the cloud) and Ehecatl (the wind).[2]

1. Hooft, Anuschka van't. *The Ways of the Water: A Reconstruction of Huastecan Nahua Society*. Leiden: Leiden University Press, 2007. 233.

2. González González, Mauricio, and Sofía Medellín Urquiaga. *Pueblos indígenas de México y agua: nahuas de la Huasteca*. UNESCO. 14. Accessed on the Web, Sept. 5, 2013.

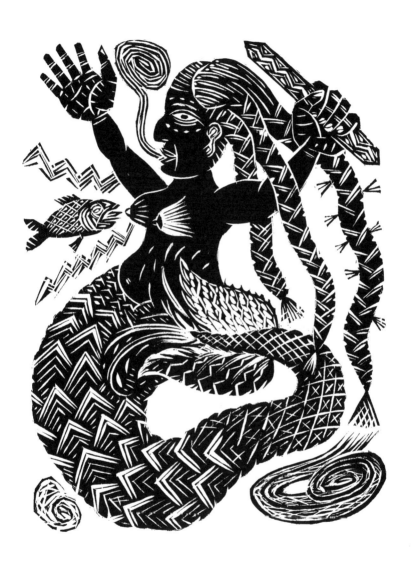

EL SOMBRERO

Tantoyuca, the municipality in Veracruz with a long tradition of weaving *morrales* (shoulder bags) from the *zapupe* agave, is also a producer of hats made from the royal palm. This bountiful tree that thrives along Mexico's Gulf Coast has many uses. It bears a nutritious fruit as well as providing the basic materials to build a house. Grazing cattle benefit from the palm's ample shade and birds nest in its branches, while its deep root systems help prevent erosion.

The type of sombrero known as a *tantoyuquero* has become emblematic of the whole Huasteca region. Historically, hats have been worn to affirm regional identities all over rural Mexico. To make the *sombrero tantoyuquero*, large leaves harvested from the royal palm are cut into thin strips and then plaited into long strands. These are sewn together in a spiral fashion to form the durable wide-brimmed hat. When a black, red or brown leather trim, called a *ribete*, is woven into the outer edge, the hat is described as *ribeteado*. This decorative feature protects it where it is most likely to fray. The colour of the *ribete* once had a special significance. The use of black or red-brown indicated whether the person still had parents. A brown *ribete* was reserved for spiritual advisers and a black *ribete* for elderly men.[1]

1. Güemes Jiménez, Román. *Cultura desocupada.* IVEC, 2005. 60.

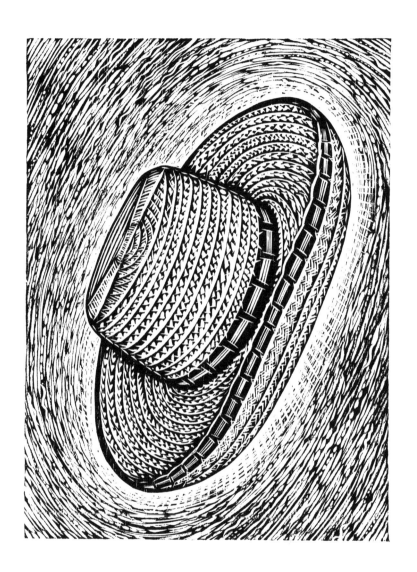

EL TAMBOR

Carnival revellers in Santa María Apipilhuasco, a remote Otomí village in the municipality of Ixhuatlan de Madero in Veracruz, move to the steady beat of a lone musician. While one hand holds a small reed flute the other maintains a steady rhythm on a square double-sided drum, *el tambor*. It is customary for him to begin playing two weeks prior to carnival in order to summon Zithu from the underworld. This deity, depicted on one side of the drum as the Devil, governs the population's behaviour during the festivities. He is a complex entity able both to harm and to protect.[1]

The ceremony is led by an elderly singer, dressed in a loosely fitting suit made from burlap sacks, who leads the procession of dancers from house to house. The black cloth mask covering his entire head has a long twine moustache sewn into it and small white painted eyes. Representing an ancestor from the Otomí peoples' remote past, he officiates the rituals intended to bring well-being to the community. His ancient songs, remembered by a handful of men, are accompanied by the drum and flute. For the duration of carnival the *huapangueros* wait expectantly nearby, ready to take over the moment there is a pause in the drummer's song. These are musicians who play *sones huastecos* and in this context they must also know a repertoire of instrumental carnival music. Masked dancers punctuate the music with shrill exclamations that echo in the still mountain air.

1. Croda León, Rubén. 'Una mirada a los carnavales indígenas del norte de Veracruz.' *Los rostros de la alteridad*. Ed. Lourdes Baéz Cubero and María Gabriela Garrett Rios. Veracruz: COVAP, 2009. 152.

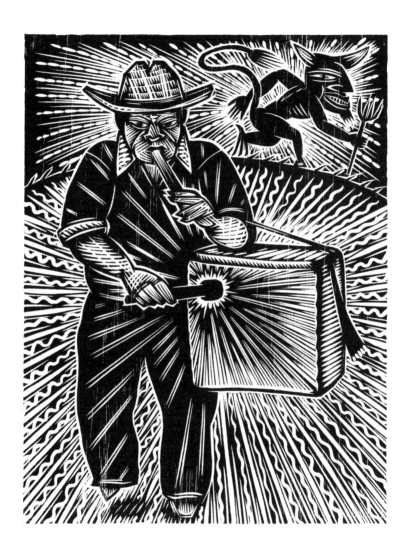

EL TARANGO

This temporary wooden structure is built for musicians to play on during *huapangos*. It is also known as *cuauhtlapechtli*, a Nahuatl word meaning 'wooden bed'. The scaffolding has a small roof and is usually assembled at one end of the flat terrain, such as a town square, where dancing will take place. Banana leaves and garlands of flowers are often part of the decoration. The musicians must clamber up a small ladder to the place where they will be seated and seen by the audience.

According to anthropologist and *huapanguero* Román Güemes, the customary removal of the ladder during the performance was not intended to prevent the musicians from getting down. Rather, taking the ladder away kept other people, such as eager drunks, from interfering with the music-making or perhaps dipping into the musicians' supply of liquor. Several bottles dangle within easy reach of the players, so it is not surprising that the occasional squiffy musician has veered off the edge of the *cuauhtlapechtli*. In the Sierra Gorda region of Guanajuato and Querétaro, two of these stages are placed opposite each other for the protracted poetic exchange between rival troubadours.

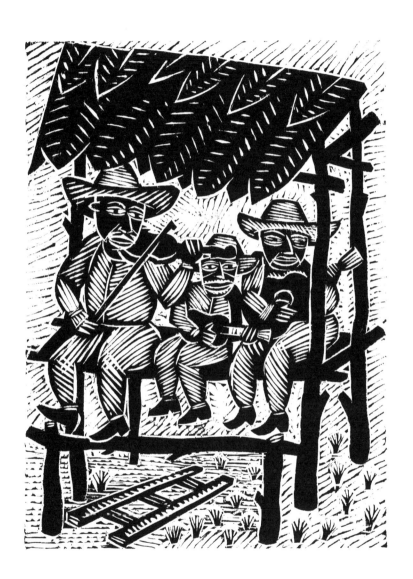

EL TECOLOTE

In many parts of Mexico, *tecolote* is the preferred word for 'owl' rather than the Spanish *búho*, *lechuza* or *mochuelo*. Mexican associations with the nocturnal predator include witchcraft, and the owl's call is construed as a bad omen. In Nahua mythology, *el tecolote* is one of the incarnations of Tlacatecolotl ('the owl man'), as well as a synonym for the Devil. This complex and multi-faceted deity, married to Meztli (the moon), assists the sun on its nightly journey through the underworld. One myth describes his abode as having originally been on a mountain called Xochicoatepec (Mountain of the Floral Serpent). He fled this abode, however, along with other gods from nearby mountains when they were no longer respected on earth.

He presides over a celebration called Nanahuatilli (the Nahua word for 'carnival'), during which the inhabitants of the underworld roam freely among humans. Before celebrations begin, Tlacatecolotl appears in the dreams of the carnival leaders as well as the dancers. Public and private rituals are performed in his honour, thereby ensuring a successful celebration. Offerings to Tlacatecolotl include ceremonial paper, food, candles, music, the blood of birds and *aguardiente*. For the duration of carnival Tlacatecolotl lends his *tonalli* to the dancers, giving them special healing powers.[1] Located in the head, *tonalli* is the animating force inherent to all things and does not disappear after death.[2]

1. Báez-Jorge, Félix, and Arturo Gómez Martínez. 'Los equilibrios del cielo y la tierra. Cosmovisión de los nahuas de Chicontepec.' *Desacatos*. Mexico: 2000. 82, 90.

2. Gómez Martínez, Arturo. *Tlaneltokilli: la espiritualidad de los nahuas chicontepecanos*. Mexico: Ediciones del Programa de Desarrollo Cultural de la Huasteca, 2002. 77.

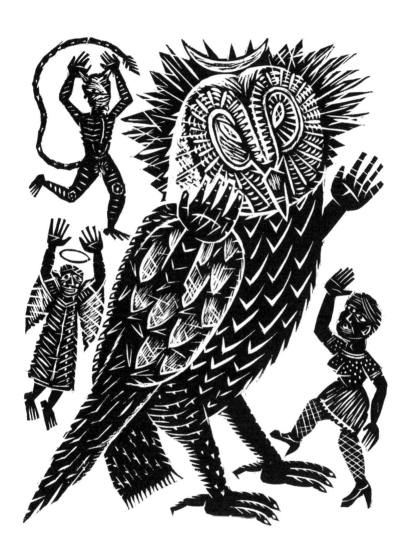

EL TELAR DE CINTURA

Backstrap weaving is an ancient technique often associated with Guatemala, where Mayan women from the Western Highlands have practised this art form for countless generations. Textiles were produced using the backstrap loom all over Mesoamerica and women were expected to weave regardless of their social standing. An uninterrupted tradition of backstrap has been maintained in various parts of Mexico as well. Although the use of the loom has declined in the Huasteca, cloth is still made in a few villages, such as Achupil in the municipality of Chicontepec, Veracruz.

In the past, not being able to weave could undermine a young woman's marriage prospects as she was expected to make clothes for her own use along with textiles that could be traded. Until the early twentieth century, fabrics were still used for barter in the Huasteca. In Santa Ana Tzacuala, Acaxochitlán, in the state of Hidalgo, there is a community where a miniature version of a loom is placed in a girl's crib until she can walk, to ensure that she will be a good weaver later in life. A similar practice was observed by the Franciscan monk Fray Toribio de Benavente in the sixteenth century. He describes in his 'Memoriales' how a newborn girl would have a spindle or some other part of the loom put in her hand.[1]

1. Stresser-Pean, Claude. 'Un cuento y cuatro rezos de los nahuas de la región de Cuetzalan, Puebla.' *Estudios de cultura nahuatl.* Mexico: 2003. 34, 428.

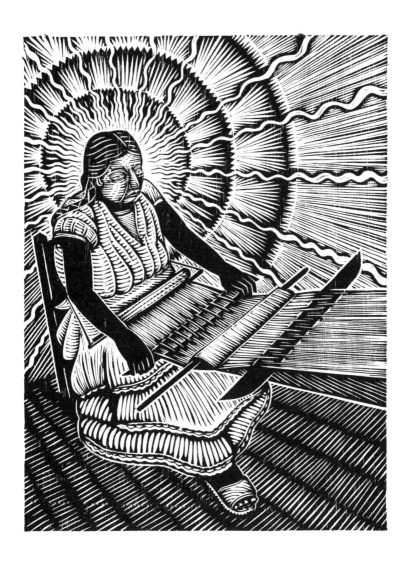

EL TOPO

Topo Chico was one of the first soft drink companies in Mexico, and the first to obtain a franchise to bottle Coca-Cola. Perhaps this is why a quarter litre of *aguardiente*, often served in used pop bottles, has come to be known as *un topo*. *Aguardiente* made from sugar cane (also called *caña* or *vino*) is the most common alcoholic drink in the Huasteca.

The spirit is used in a variety of ceremonies. To offer someone *un topo de aguardiente* is a way of sealing a pact or establishing a bond such as that between *compadres*. In lieu of a written contract, the public offering of *aguardiente* is a way of formalizing an agreement. A situation like this may require that the person being offered *aguardiente* refuse it several times to show that he is not motivated by greed. In the case of a transgression within the community, the offender may be required to make a large public offering of *aguardiente*. Acceptance of the *aguardiente* signifies that the individual is being allowed back into the community. As part of agricultural ceremonies a small quantity of liquor is poured onto the ground as a libation. During a wake, *aguardiente* is consumed to strengthen the souls of those present so that the cold soul of the deceased cannot enter their bodies.[1]

1. Hooft, Anuschka van't, and György Szeljak. 'Consumo de alcohol, valores comunitarios y modernización en una comunidad nahua.' *Espaciotiempo* 1. Madrid: 2008. 64.

EL TRAPICHE

Countless circles are etched into hardened earth around the sugar mill as a weary donkey is prodded by a farmer. Meanwhile, stalks of sugar cane that have been fed into a rotating cylinder fall flattened to the ground. Under an adjacent shelter, large steaming cauldrons, resting on stone ovens, are fuelled by the chaff dried in the sun the day before. The reduction process is eyed watchfully until the sweet essence is thick enough to be poured into the clay moulds used to make *piloncillo*.

The economy of several indigenous communities in the states of San Luis Potosí and Veracruz has revolved around family enterprises like this since the seventeenth century. In the Mexican context *trapiche* is both the mechanism used to extract sugar cane juice and the overall installation required to produce *piloncillo*. A *trapiche*, which Fray Bartolomé de las Casas mentions in his 'Historia de las Indias' was already in operation on the island of Santo Domingo as early as 1506. Countless wooden *trapiches* and subsequently metal ones were constructed throughout Latin America in the sixteenth and seventeenth centuries as the craving for sugar developed.

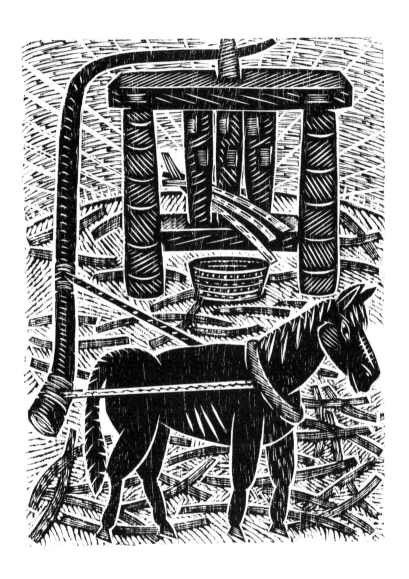

EL TROVADOR

A *trovador* is a highly regarded poet who specializes in the improvisation of verses that may be sung or recited. These humble bards, also known as *troveros*, are present at all kinds of occasions such as raucous sessions animated by *huapangueros* in the intimacy of crowded cantinas as well as formal public events in front of hundreds of people.

Themes for improvisation may range from the exaltation of a female onlooker, jovial sparring between two or more bards or praise for the patrons of the celebration. Some prepare their material in advance while others display their mental agility by improvising stanzas. Either way, it is customary to shout, 'Stop the music!' before the recitation; the violinist brings the music to a halt, providing the necessary silence for an appreciation of the poetry. When the *trovador* is finished, he or she exclaims, '*¡Que siga la música!*' ('Let the music continue!') and the *son* is quickly resumed. The ephemeral succession of verse travels across the verdant landscape like pollen in the wind. Fragments of the poetic dialogue settle and reappear transformed in new improvisations many miles away.

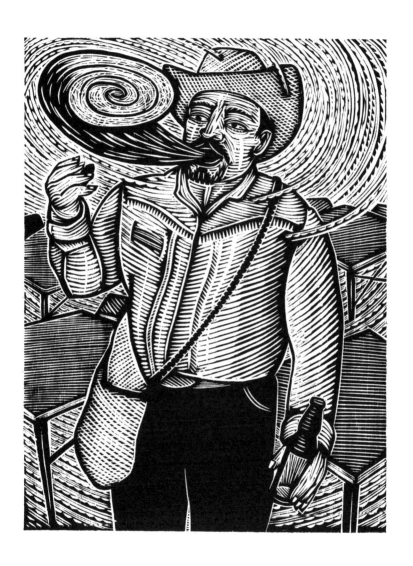

EL VIOLÍN

Ask someone in Mexico what music they associate with the violin, and *son huasteco* will be the likely reply. This regional genre features the unwavering trio format of violin with two strummed instruments: *la jarana* and *la quinta huapanguera*. The melodic part is taken by the violin with occasional flourishes played on *la quinta*. Startling arpeggios and intricate melodies, flaunted between sung couplets, prove that deft bowing has a place in the genre. However, poignant timbre, playful improvisation and rhythmic inventiveness are also important factors that dancers and onlookers appreciate.

In ceremonial circumstances the violin is often accompanied by the *quinta* alone and the violinist adheres strictly to established melodies that are repeated without significant variations. Hundreds of these instrumental songs, called *sones de costumbre*, are played in a specific order during agricultural rituals. Here the violinist is highly revered, having undergone an initiation that goes beyond simple memorization of a set of melodies. During carnival, another instrumental repertoire animates the dancers. Traditional weddings also feature the violin playing a special melody corresponding to each part of the ceremony.

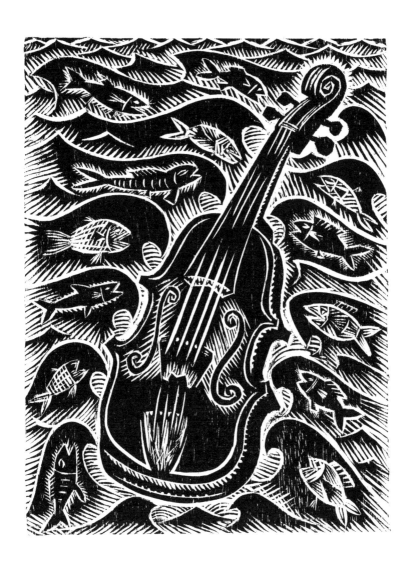

LOS VOLADORES

Tourists preparing to enter the Museum of Anthropology in Mexico City are often stalled outside by the spectacle of five men dressed in ornately decorated clothing. After ascending a tall metal pole, one remains perched on top playing a flute and drum while the others 'fly' down slowly with open arms, their ankles attached to long ropes that uncoil as they spin outwards, slowly approaching the ground. The oblique projection of the tense ropes in a circular motion suggests the sun's rays descending from the sky.

This sacred dance practised in the Huasteca is usually associated with the Totonacapan region of Veracruz. Spanish colonizers in the sixteenth century documented the widespread use of this ritual as far south as Nicaragua.[1] Traditionally, the ritual begins with a procession to the spot where a suitable tree measuring about thirty metres is felled. Metal poles, like the one outside the museum are installed permanently in places where the dance takes place frequently.

Before carnival begins, in the town of San Bartolo Tutotepec, Hidalgo, the wooden pole is erected in the town square as a conduit between heaven and earth, reinforcing the concept of this location as the centre of the universe. Preparations include digging a deep sacrificial hole on the square in which flowers, *aguardiente*, paper figures and a chicken are offered to feed the earth.[2] This is where the pole will be placed.

1. Córdoba Olivares, Francisco R. 'El volador, los cuetzalines y los huahuas, de la región poblano-veracruzano.' *La palabra y el hombre*. Mexico: 1991. 70–72.

2. Pérez González, David. *El complejo ritual otomí de la Sierra Oriental de Hidalgo*. Mexico City: ENAH, 2011. 105–106. Accessed on the Web, Sept. 8, 2013.

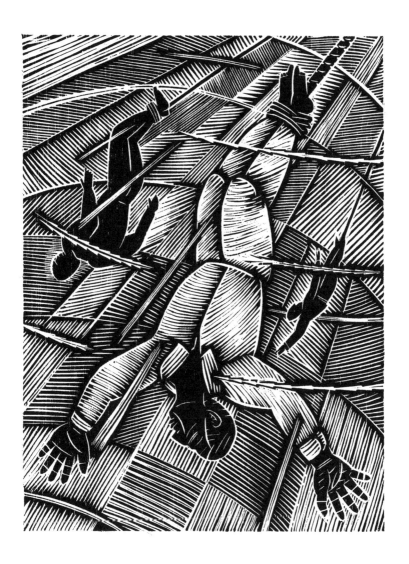

EL ZACAHUIL

This is the monumental equivalent of the tamale, an ancient and well-known Mesoamerican dish. While tamales are small portions made by steaming corn dough wrapped in banana leaves or corn husk, one *zacahuil* is sufficient for a large gathering. Rather than being steamed, *zacahuil* (a combination of crushed corn, spices and meat wrapped in several layers of banana leaves) cooks for four to six hours overnight in a wood-burning oven. When extracted the following morning, the large bundle's exterior is completely charred. An incision made along the length of the *zacahuil* allows for the steaming preparation of corn and meat to be spooned into individual bowls.

Due to the cost and laborious nature of its preparation, *zacahuil* is usually reserved for special occasions such as festivals or weekly market days. Poza Rica, an industrial city in Veracruz, has a municipal market with an area designated for *zacahuil* vendors operating throughout the week. *Zacahuil* plays an important role in the region's Xantolo ritual, featuring in the feast offered to the souls of departed relatives.

The Teenek people prepare a similar dish, called *bolim*, which they cook buried in the ground. First a fire is lit at the bottom of a pit lined with stones; then the *bolim* is set in place and covered with more stones and earth. In the municipality of Aquismón, San Luis Potosí, *bolim* is eaten by farmers during the planting ritual celebrated on May 15. After the meal, an offering is made to the Great Mother, in the field where the corn is to be planted.[1]

1. Ponette-González, Alexandra Gisele. '2001: A Household Analysis of Huastec Maya Agriculture and Land Use at the Height of the Coffee Crisis.' *Springer Science + Business Media.* 2007. Accessed on the Web, Dec. 8, 2013.

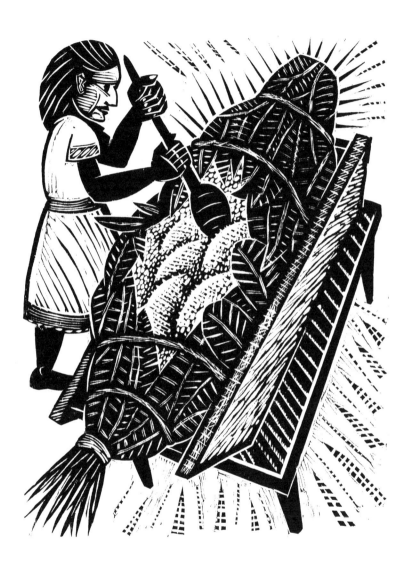

GLOSSARY

atole. A beverage consisting of tortilla dough boiled with water or milk and flavoured with a variety of ingredients such as cacao, vanilla, guava or coconut.

Aztec. Refers to the conglomeration of Nahuatl-speaking peoples who called themselves Mexicas and inhabited the area in and around what is now Mexico City. The Aztec Empire, also known as the Mexica Triple Alliance, was controlled by three city-states that formed an alliance in 1427 and spread their influence over an area extending as far south as Guatemala. The Triple Alliance invaded the Huasteca several times after 1450 and finally made them tributaries in 1505.

Bartolomé de Las Casas. A Dominican friar and scholar from Sevilla, born in 1484, who participated in the brutal conquest of Hispaniola and Cuba but went on to defend the rights of the indigenous peoples of the Americas. He lived in the Dominican Republic, Guatemala, Venezuela and Mexico. The last twenty-four years of his long life were spent in Spain where he published his most influential work, *A Short Account of the Destruction of the Indies*, alerting authorities in Spain to the atrocities of the conquest.

Codex Borgia. This pre-Columbian pictographic book, used for divination, is thought to have been created at the end of the fifteenth century in the central Mexican highlands. Its thirty-nine painted sheets can be folded in accordion fashion for storage purposes or extended to a length of about eleven metres. It was found by Alexander von Humboldt in Rome in 1805, among the possessions of Cardinal Stefano Borgia.

huapango. *Huapango* is the festive occasion when *sones huastecos* are played to accompany dancers. *Sones huastecos* are also referred to as *huapangos*. Another category of more recent compositions called *huapangos* has become a staple of the mariachi repertoire, featuring such favourites as 'El Crucifijo de Piedra', 'El Rogaciano' and 'El Mil Amores'.

huapanguero. A term applied to musicians who play *son huasteco*.

Huasteca. The Huasteca is a region of Mexico comprising large parts of the states of Veracruz, Hidalgo and San Luis Potosí and smaller areas of Puebla, Querétaro and Tamaulipas. The adjective forms are *huasteco* (masculine) and *huasteca* (feminine).

Huasteco. Historically Huastecos or Cuextecas were terms used by the Mexicas when referring to the inhabitants of a large coastal region extending inland to the foothills of the Sierra Madre from the Gulf of Mexico. Recently, anthropologists have begun to use the term Teenek instead of Huasteco, as it is the name the peoples use to define themselves. Now it is common for the mestizo population of the region to refer to themselves as Huastecos.

Mesoamerica. Mesoamerica is a historic and cultural region encompassing Mexico, Honduras, Belize, Guatemala and El Salvador. It is considered one of the cradles of civilization.

música ranchera. A popular genre of Mexican song that originated in the early twentieth century. Initially the lyrics focused on characteristics of rural life but the range of subject matter was expanded by composers such as José Alfredo Jiménez and Manuel Esperón. Their contribution to the Great Mexican Songbook includes heart-wrenching declarations of unconditional love, nationalistic anthems and odes to tequila.

Nahua. The Nahuas are the largest indigenous group in the southern part of the Huasteca. They moved into the area in two waves, the first around AD 800 and the second in AD 1500.

Nahuatl. The multiple variants of Nahuatl that persist today constitute the most widely spoken vernacular language in Mexico. The Mexicas, also referred to as Aztecs, whose vast empire reached its zenith during the fifteenth century, spoke what is now called Classical Nahuatl.

ofrenda. An offering made to a deity. Often consists of food, candles, incense and flowers, arranged on a table. Elaborate *ofrendas* are

assembled for the Xantolo celebrations. Music and dance are also considered *ofrenda*s.

Otomí. The Otomí have inhabited central Mexico for thousands of years. Variants of the Otomí language are spoken in a number of distinct communities in the states of Hidalgo, Mexico and Querétaro. In the area of Pahuatlán, Puebla, they call themselves N'yühü, as opposed to Otomí, a word applied to them by Nahua-speaking people.

pulque. A drink made by fermenting *aguamiel*, the sap extracted from the heart of the agave plant.

Purépecha. Spoken mostly in the highlands of the state of Michoacan, Purépecha is an isolate language with no similarities to other Mesoamerican languages.

Quetzalcóatl. The feathered serpent, an important deity of ancient Mexican religion, associated with death and resurrection. During the reign of the Aztecs he was venerated as a god of learning. He is also represented as a man with a beard.

son. Used extensively within the context of Mexican folk music, rather than the word *canción* ('song'). *Sones* are musical forms that are open to different degrees of improvisation, whether it be rhythmic, melodic or poetic. Each *son* has a basic harmonic progression and rhythmic structure that are adhered to.

son huasteco. This genre of folk music, played by trios comprised of violin, *jarana huasteca* (a small five-string guitar) and *quinta huapanguera* (a deep-bodied guitar with five or eight strings), is one of the most characteristic attributes of the region. The extensive repertoire consists primarily of anonymous songs called *sones huastecos*.

Teenek. The Teenek, historically referred to as Huastecos by the Nahuatl-speaking people of central Mexico, are the cultural group with the longest presence in the Huasteca. Their language, also called Teenek, is the northernmost branch of the Mayan language family

with about 3,500 years of separation from Proto-Mayan, the common ancestor of the many types of Mayan spoken today.

Tenochtitlán. The largest city in Mesoamerica at the time of the Spanish Conquest and the capital of the Aztec Empire.

Tepehua. The Tepehua peoples inhabit a mountainous region of Puebla, Veracruz and Hidalgo. The word is thought to mean 'citizen' or 'inhabitant of the mountain'. A characteristic of the Tepehua language is that certain phrases can be whistled.

Tezcaltipoca. An Aztec deity associated with the jaguar and with concepts such as war and temptation.

Toribio de Benavente (Motolinia). A missionary, born in 1482, who arrived in Mexico in 1524 with a group of twelve Franciscans. He is known for condemning certain abuses committed against the indigenous population, such as slavery and taxation, but he promoted their conversion to Catholicism by any means. Motolinia, meaning 'wretched', is the Nahuatl name he adopted after hearing it applied to him and his companions. The chronicles attributed to him are an important source of information regarding Mexican culture at the time of the conquest.

Totonacapan. A region in northern Veracruz, inhabited by the Totonac people. At the time of the Spanish conquest their realm was twice as large, extending west into what are now Puebla and Hidalgo, and as far south as the Papaloapan river.

Totonaco. The Totonaco people live in an area called Totonacapan, which spreads across the borders of Veracruz, Puebla and Hidalgo. One theory suggests that the word is a composite of *tutu* ('three') and *nacu* ('heart'), relating to three ancient ceremonial centres: Tajín, Zempoala and Yohualichan.

voladores. The *voladores* ceremony is a sacred 'flying' dance in which four dancers climb to the top of a tall pole made of a tree trunk and fasten themselves to ropes coiled around it. With arms outstretched,

the dancers let gravity unwind the ropes as they circle slowly to the ground. A fifth participant remains at the top playing a flute and drum.

Xantolo. In the Huasteca, the Day of the Dead celebration is more commonly known as Xantolo. Although *sanctorum* is the Latin origin of the word, it is understood to mean 'celebration of the dead'. The complete Latin phrase is Festum Omnium Sanctorum (All Saints' Day).

zacahuil. The most characteristic dish of the Huasteca, it is usually described as an enormous tamale. While most tamales are steamed, a *zacahuil* is baked in a special wood-burning oven.